# A Time to Harvest

The Farm Paintings of Franklin Halverson

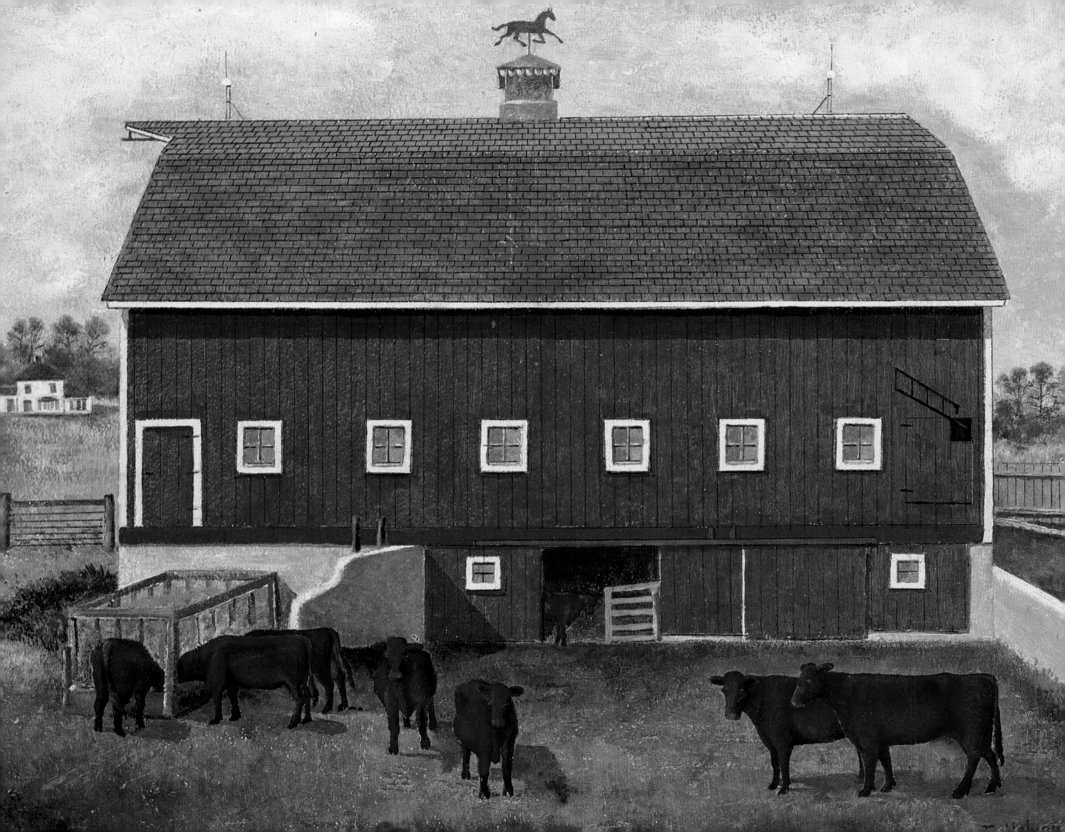

# A Time to Harvest

## The Farm Paintings of Franklin Halverson

Stories by Bob Barnard

With Introduction by Philip Martin

Midwest Traditions, Inc.
Mount Horeb, Wisconsin
1993

Midwest Traditions is a nonprofit educational organization devoted to the study and preservation of the folk arts and traditional cultures of the American Midwest. Our publications help to bring this rich, diverse heritage to broader public attention. Midwest Traditions also sponsors field research projects and public exhibitions of folk art and serves as a clearinghouse for information on other regional programs and resources for cultural conservation.

For a free catalogue of books, frameable art-prints, music cassettes, and other materials distributed by Midwest Traditions, write:

Midwest Traditions
P.O. Box 320
Mount Horeb, Wisconsin 53572
(or call toll-free 1-800-736-9189)

Special thanks to the Wisconsin Arts Board, State of Wisconsin, for their support of this rural heritage documentary project.

This book was created in cooperation with the Wisconsin Folk Museum of Mount Horeb, Wisconsin.

ISBN: 1-883953-04-9

Manufactured in the United States of America
Printed on acid-free paper
This is printing number: 10 9 8 7 6 5 4 3 2 1

Book Design: Lisa Teach-Swaziek, PeachTree Design
Editor: Philip Martin
Printer: Park Printing House, Ltd.
Color Separations: Four Lakes Colorgraphics Inc.

## Publisher's Cataloging in Publication

Barnard, Bob, 1920-
    A time to harvest : the farm paintings of Franklin Halverson / stories by Bob Barnard ; introduction by Philip Martin.
       p. cm.
    Preassigned LCCN: 93-78987
    ISBN 1-883953-04-9

    1. Halverson, Franklin, 1982-1989 — Themes, motives.  2. Farm life in art.  3. Farm life — Middle West — History.   I. Title

ND237.H359B37  1993        759.13
                               QB193-972

## Photographs and Line Drawings

The photographs and line drawings in the introduction are from the following collections and are reproduced courtesy of:

Sioux Rapids Area Historical Association: p. 8, p. 9 (upper L), p. 10 (lower R), p. 11 (bottom), p. 14 (2 photos), p. 18 (2 photos), p. 20;
Buena Vista County Historical and Genealogical Society: p. 11 (upper L), p. 12 (bottom);
Albert City Historical Association: p. 19 (bottom);
Michele Burr Mickelson: p. 12 (upper R), p. 13 (left);
Bob and Ruth Barnard: p. 16 and p. 17 (4 photos);
Dr. and Mrs. Arnold Olson: p. 13 (right); p. 15 (lower L);
Aubrey and Ruthe George (originally published in *Des Moines Sunday Register*, Maurice Horner, photographer): p. 21, also detail p. 15 (upper R);

## Paintings in Book

The oil paintings and illustrations by Franklin Halverson in *A Time to Harvest* are reproduced by special permission from the Estate of Franklin Halverson and with the cooperation of individual owners. Unauthorized reproduction is strictly prohibited. For further information, contact Midwest Traditions, Inc.

Most originals are in private ownership, but a small number are on public display, at: the Sioux Rapids Historical Museum; the 1st National Bank of Sioux Rapids, and the Buena Vista County Courthouse in Storm Lake, Iowa.

For additional information on the paintings, see p. 111.

The painting on the frontispiece is "Frank Colburn's Barn," and the painting on p. 5 (opposite page) is "Pioneer Homestead."

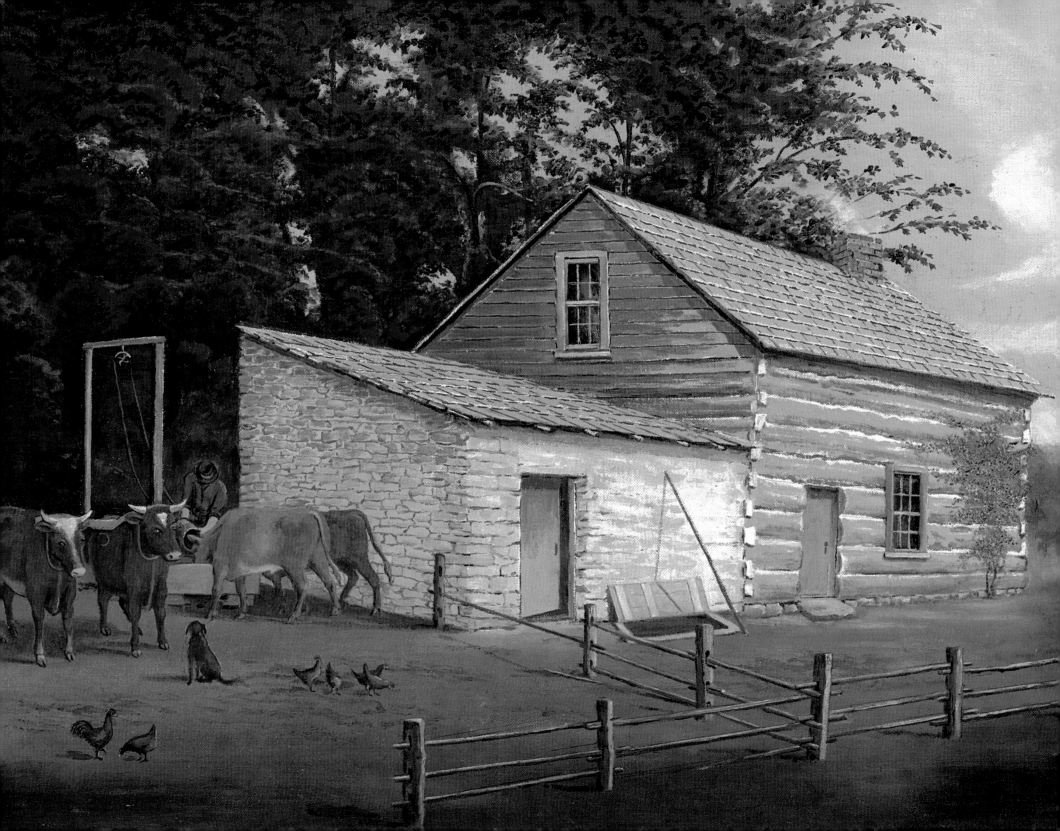

This book is dedicated to the memory of Arden Hamrick (1928-1992) of Webb, Iowa, whose vision and dedication to bring this collection of paintings to public attention made this book possible.

# TABLE OF CONTENTS

# INTRODUCTION

*"I'm writing my memoirs with a brush!"*

Franklin Halverson

Welcome to a remarkable glimpse of American farm life around the turn of the century: the farm paintings of the late Franklin Halverson of northwest Iowa. Of Norwegian-American heritage, Albert Franklin Halverson (1892-1989) was born on a prairie farm just about four miles from the small town of Sioux Rapids. Created late in his life, Halverson's memory paintings capture the folkways of rural life in the early 1900s, based on his own experiences growing up on a farm.

Besides being a farmer, Halverson trained as a draftsman and for many years did commercial illustrations for area farm-machinery manufacturing companies. An eye for technical precision dominates his paintings. At first, he sold no paintings and told very few about his work. Gradually, his documentary efforts became known locally, but he still kept the paintings at home, hoping eventually to create a permanent collection in a museum somewhere. Only in the very last years of his life, before entering a nursing home, did he decide to sell his paintings to local friends and neighbors.

The paintings in *A Time to Harvest* are accompanied by the stories of another senior farmer from the area. Bob Barnard was born in 1920, nearly thirty years after Halverson, and grew up not far from Sioux Rapids in Gillett Grove, also on the Little Sioux River. Barnard never met Halverson; the stories reflecting on Halverson's illustrations are based mostly on accounts Bob heard as a youngster from elder farmers of Halverson's generation. He also weaves in his own personal tales of life as a farm boy in the 1920s, an era when farms were still worked with horses and much handwork.

Together, these two voices present a stereoscopic portrait of the small family farm in the early 1900s. Halverson's paintings in particular are a priceless visual record of a deeply-rooted rural heritage of the American Midwest. These illustrated memories should be seen as a national treasure, the equivalent of an important historic building or natural bio-preserve of great value. The combination of Halverson's detailed paintings with Barnard's eloquent personal commentary

The beautiful Little Sioux River offered fresh water, hardwood, and wild game to early settlers. Photo 1910.

LITTLE SIOUX RIVER, SIOUX RAPIDS - IA.

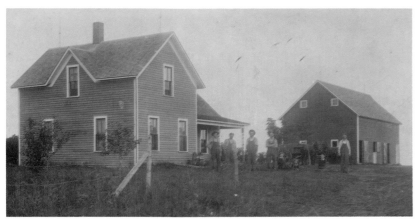

reveals a richly-textured folk knowledge—a complex mix of time, place, and traditions of work, family, and neighborhood.

The Wisconsin Folk Museum and its publishing affiliate, Midwest Traditions, Inc., have collaborated to produce this documentary collection of Halverson's farmlife paintings. In 1990, the Folk Museum produced a similar book, *Threshing Days*, on the paintings of a southern Wisconsin farmer, Lavern Kammerude.

In the spring of 1991, Don Muhm, senior farm editor of the Des Moines Register, wrote a feature story on *Threshing Days*. Soon after, a fellow from northwest Iowa brought Halverson's work to my attention. Arden Hamrick owned several of Halverson's paintings and knew of many more in the area. He sent some photos to the Folk Museum and in May, 1992, organized an exhibition of Halverson's paintings at the Arts on Grand art center in Spencer, the county seat of Clay County, just sixteen miles from Sioux Rapids. I came to see the show and was very impressed. The Folk Museum received permission from the Estate of the late Mr. Halverson to produce this book, and *A Time to Harvest* was ready by fall, 1993.

In an intriguing coincidence, the Halverson family settled first in southern Wisconsin in the 1860s. They bought land just a couple of miles from the Kammerude family, whose descendant Lavern would paint the series of paintings published in the book *Threshing Days*. The Halverson family ended up moving westward, leaving the hilly farmland of southern Wisconsin to settle on the open prairie plateau of

northwest Iowa. Instead of nearly being neighbors, the Halversons and Kammerudes ended up about 300 miles apart, each producing a farmer-artist who painted a history of farming in his respective locale.

In some ways it is a mere coincidence. In other ways, it reflects the westward sweep of the farm heritage of the Midwest. Immigrants arrived, searched for good land, worked as hired hands for earlier settlers, and sent for their families to join them. They often relocated from one area to another, following oral reports and scouting trips. Each family looked for a good spot to establish a farm and bring up children.

Over decades, families grew and did their best to prosper. They raised crops and animals on good land and poor. Parents watched their children grow up, mingle, and marry, and helped them inherit the homeplace or buy nearby farms. Over time, as agricultural progress and economic growth spun around them like the weather, they passed family farms down through generations.

*A Time to Harvest* is the story of one place and of the whole Midwest. It reflects a pattern of family memories, farm stories, and township histories across the region from settlement in the mid-1800s to today.

Each area developed its own farming traditions. Climate, soil and terrain, ethnic backgrounds, local traditions, and happenstance created a finely-textured mosaic of farming folkways. Despite incredible diversity, this mosaic is mostly invisible to the non-farmer who tends to think of farming as a simple lifestyle.

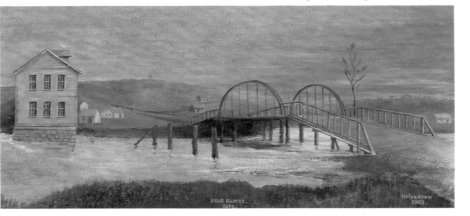

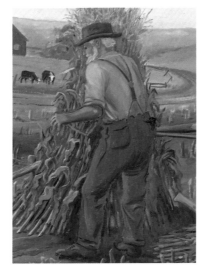

Farmers—both men and women engaged in running a farm—recognize the rich complexity of their lives. Local specialists, their memories are tuned over generations to the natural phenomenon and human heritage of a particular place. Patterns of people and nature are carefully observed, recorded in notebooks and unspoken instinct, and considered before each decision, large or small. This organic knowledge is so familiar, and so complex, that most farmers would not try to explain it to a non-farmer.

• • •

*It is one of the best towns in Buena Vista County. ... The country around Sioux Rapids is very rich and pretty. It is almost entirely composed of that grand rolling prairie which has made the names of Iowa, Minnesota and South Dakota famous throughout the civilized world.*

*... The writer does not hesitate to predict that when Northwestern Iowa shall have time to develop... it will be the most beautiful country that the eye of man ever beheld.*

from "Progress and Resources of Sioux Rapids, Iowa," by J.F. Cooley; promotional booklet, price 10 cents, printed 1895.

Imagine the first pioneers, after crossing endless stretches of tall-grass prairie, descending into the green valley of the Little Sioux River. Here was fresh, cool water, running past sandy banks. Numerous hardwood trees offered wood for cabins and fireplace fuel. There were hazelnuts, wild plums, gooseberries, grapes, and crab apples. Fish swam in the river, and deer roamed the woods.

It was such a tempting place that the first government surveyors coming into the lush, green valley in 1855 instantly staked out their own claim to the area, despite this being prohibited. They returned next year, joined by a few settlers they had met on the way. By the 1860s the town had a sawmill, a grist mill, and a general store. By the 1880s, the Chicago and Northwestern Railroad had put a line through town, and the town boasted a prospering main street. The 1885 census listed the town population as 616 inhabitants.

Up on the prairie, 75 feet higher than the river bed and stretching out in all directions, farms were appearing, growing, spreading with new settlers and family additions. The prairie that surrounded them had an awesome grandeur. Its waving

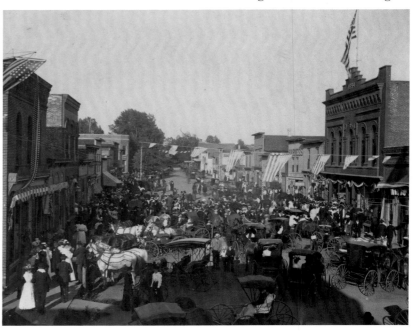

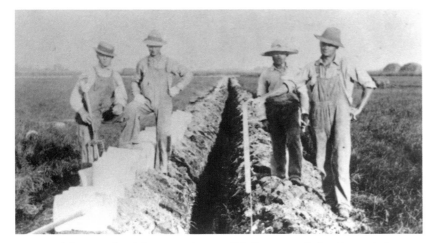

areas began to be systematically drained by ditches or underground lines of clay tiles, creating new farmland and lots of business for tile factories which sprang up in many towns.

grasses bloomed with countless wild flowers. It harbored thousands of prairie chickens. Wild ducks nested in the wet prairie sloughs. Sandhill cranes circled overhead on their spring migratory routes.

While it was a land of plenty, it was also a land that took its share. Vast prairie fires burned homes. Tornados uprooted trees and leveled barns and houses. In the mid-1870s, years of grasshopper plagues devastated crops.

The settlers built, and rebuilt, their cabins, clapboard houses, and outbuildings, and farmed as best they could. They planted many orchards for windbreak and fruit, encouraged by a government tax credit for tree planting. At first they farmed mostly the high ground, as much of the inland prairie was wet with ponds or marshy stretches. The thick, clay soil had poor drainage. Numerous pot-holes or depressions collected water in ponds and sloughs—a blessing to wildfowl, an impediment to the farmer. Later, beginning in the early 1900s, the low

*There is now scarcely any free land east of the Missouri river; but there is something much better, and that is cheap deeded land in a country already settled. The new-comer is here no longer a pioneer. The pioneering was done fifteen, twenty or thirty years ago. He can now buy land with prices varying, according to improvements. He finds himself with neighbors all around him. School houses and churches have been built. Railroads run through all localities. Towns have sprung up everywhere. The man who comes to Northwestern Iowa can get the benefits of lands reasonably without undergoing the hardships and inconveniences of pioneer life. ... Experience has taught just what can be done and how best to do it. Barring accident of drought and hail, which are incident to any country, the farmer knows that harvest will certainly follow seed-time.*

J.F. Cooley booklet, 1895

Hundreds of miles of ditches were dug by hand across the region to drain wet pockets of prairie for farming.

The Minneapolis & St. Louis railroad bridge crossed the river to connect the prairie expanses at Sioux Rapids, 1910.

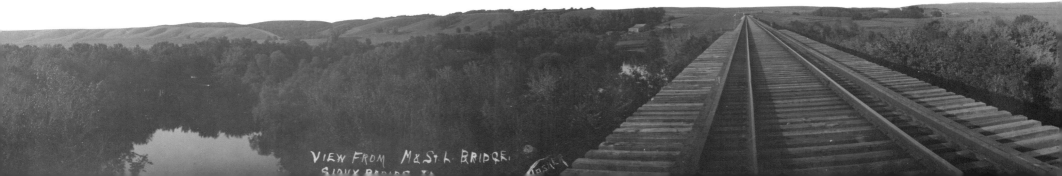

VIEW FROM M&St.L BRIDGE SIOUX RAPIDS IA

To this rich, wild, fruitful prairie land came the Halversons and many other Norwegian families. They were following trails blazed by fellow immigrants who arrived in the Midwest throughout the latter half of the 1800s. In Norway, this was a period of crop failure, famine, overcrowded farms, and a growing "America fever" fueled by reports of level, rock-free Midwestern farmland nearly free for the pioneer.

*The population in point of nationality is exceedingly diversified, but it is proper to say that the inhabitants of Northwestern Iowa are exceptionally choice extracts from nearly all the principal nations of the globe.*

J.F. Cooley booklet, 1895

Franklin Halverson's grandparents Ole and Kari Bakken Halverson came from the mountains of Valdres province in central Norway to the hills of Wisconsin. In 1861 they bought a farm of 20 acres for $150 in Wisconsin's south-central Green County, near the town of Argyle. In the Civil War, Ole Halverson was called up to report for service, but when he showed up they had filled the needed quota and he was allowed to go home again.

In 1869 the Halverson family decided to move to Iowa. Ole and his eldest son Albert went ahead to scout a good location, with Ole riding in a wagon and Albert riding a horse. Albert later told his son Franklin the most excit-

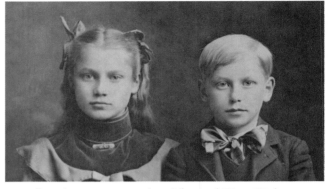

ing thing about the trip in his eyes was that, only 14 years old at the time, he got new boots and a revolver.

According to family memoirs, the Ole and Kari Halverson family settled in Iowa first in Franklin County near the little village of Geneva. Then, perhaps in 1882, the family moved again, to Sioux Rapids in northwestern Iowa.

Two year earlier, in 1880, Elizabeth Christenson had brought her children to Sioux Rapids after the death of her husband. In 1882, the same year the Halverson family arrived, the widow Christenson bought a piece of land on the prairie. The tract was located in Lee Township, about four mile southeast from town, on a high, windy spot. The land was purchased from the Chicago and Northwestern Railroad. A historic pioneer route, the Fort Dodge Trail, ran right past the land.

Two years later, in 1884, the Halverson and Christenson families joined with the marriage of Elizabeth's daughter, Tonette, to Albert Halverson, then 29 years old. They lived for a while in town where their first two children, Clara and Effie, were born. Then, in 1891 the family moved onto the prairie land purchased by Tonette's mother, into a home Albert had prepared. The next year, 1892, they had a son, christened Albert Franklin Halverson.

• • •

A young Franklin Halverson, with his older sister Effie.

Threshing was a community event. The powerful steam-engine and grain separator traveled from farm to farm to process each neighbor's grain. Early-1900s crew, Newell, Iowa.

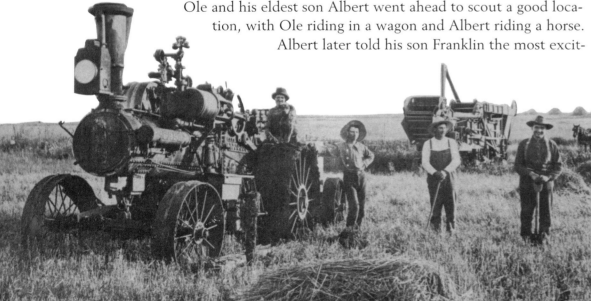

Franklin, as he was known to most, attended a country school where he first became interested in art, for which he won prizes. Mostly, though, like other farm boys, he had plenty to do on the farm. The family farm was a small one, just eighty acres, with some wet lowlands. Like their neighbors, they milked cows, raised chickens and hogs, grew corn and oats.

In 1918, at the age of 26, Franklin enlisted in the army and served in Europe during the first World War. He recalled

many times his service in Alsace-Lorraine, the site of fierce fighting and tiring marches under a 60-pound pack. At the end of the war, he was stationed on the Swiss border. He carried a sketchbook and made drawings of many places he saw in France and on hiking trips in Switzerland.

In June 1919 he returned to Iowa. He was awarded a scholarship to an art school, but turned it down. His father had suffered a stroke, and Franklin decided to work on the family farm.

He did enroll in a correspondence course in commercial art through Columbia University, and in the mid-1920s was sending in his drawings for critical review. He received a diploma and by the late 1920s was busy with freelance work,

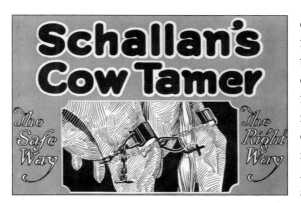

HAND ME ONE OF THOSE COW TAMERS
WHILE I THINK OF IT.

This card will make them buy Cow Tamers without effort on the part of the merchant. Simply lay Cow Tamer on counter or in window, insert card as shown here and have a few boxes of Cow Tamers in sight. Every farmer and dairyman has use for this item and will buy sooner or later. Goods well displayed are half sold.

SIMONSEN IRON WORKS, Sioux Rapids, Iowa
Sole Sales Representatives

doing illustrations for patent applications and sales catalogues for farm-equipment manufacturing companies across northwest Iowa. As one of very few accredited commercial artists in the area, he did artwork for many different companies.

His father Albert passed away in 1944. Then in his early fifties, Franklin worked the family farm on his own for a few years, using a team of horses and a Theiman tractor, a model produced in nearby Albert City. A few years later, Franklin rented out the farm to neighbors Junior and Barbara Halverson (no relation to Franklin), and accepted a full-time job heading the art department of a farm-equipment company, Twin-Draulic, Inc., located in the town of Laurens, some fifteen miles east.

The job allowed him to live on and maintain the home farm and support his two unmarried sisters, Clara and Effie, and his mother Tonette. Near the main house he built a large studio where he worked on weekends. The studio was a pleasant, spacious room with cobblestone fireplace and high, beamed ceiling.

In 1958 his mother died, at age 105, and a year later his sister Effie also passed away.

At this point, he and his sister Clara lived alone on the

Norwegian Lutheran Church gathering, early 1900s, Sioux Rapids.

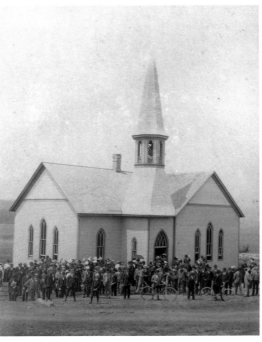

Norwegian Lutheran Church gathering, early 1900s, Sioux Rapids.

farm. Now in his late sixties, Franklin began to paint his historical paintings in earnest. Most of the scenes featured in this book were done in this period of the 1960s. His neighbors were good friends and took care of his farm like it was their own. When they stopped in to visit, he would take them out to the studio. With work-table and benches overflowing with technical drawings and sketches, he would show them the paintings he was working on.

He said he was writing his "memoirs with a brush," documenting farm scenes from his youthful days around the turn of the century. To several people, he described his work as a "collection" that he hoped would be displayed in a museum someday. He did not sell any of his paintings, nor did he make a big deal of them. He just framed some, stacked others unframed in corners, and kept working on new ones. He painted, he said, because he enjoyed it.

Keeping extensive scrapbooks, he traveled around the area to old-time threshing events and historical sites. In the late 1960s he was president of the Buena Vista County historical society, and he and his sister Clara would eventually donate a complete parlor of their family furniture for a display at the county museum.

The Little Sioux River provided power to grind grain for the local flour mill. Halverson made a painting of the mill in 1961, possibly from this 1910 photo.

In the 1970s, he and his sister Clara moved into Sioux Rapids. While living in town, he still returned as often as he could to his favorite place, his farm studio, to paint.

In Sioux Rapids, he lived across the corner from G. Richard Burr. Richard's daughter, Michele Burr Mickelson, recalls Franklin visiting them for Sunday dinners. She in turn interviewed him for a family genealogy project. In 1978, she gained the courage to ask if he would sell a painting. "Well, you could buy this one," he said, pointing to a painting on the wall showing a pioneer home. "How much do you want?" she asked. "I don't know, what do you think?" he replied. She offered him several hundred dollars, and he accepted. He also showed her the rest of his collection, many in back rooms, hanging on walls and stacked, unframed, on the floors.

He told Michele he generally took seven to ten days to do a painting. Drawing from his memories, he also studied historical photographs and illustrations he had collected over the years. Not always completely satisfied with his work, he said his sister was his best critic. Noting that a tilt of a horse's head was not quite right, he would point out, "A horse just wouldn't react that way if it heard a noise behind it." He took care to render details as accurately as he could.

Eventually, he began to enter his paintings in various art shows. He took delight in attending the shows and strolling around, unidentified, to hear what people were saying about

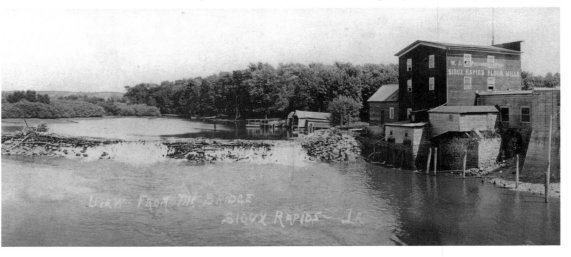

VIEW FROM THE BRIDGE SIOUX RAPIDS IA

his work. As he told Michele, what pleased him most was seeing "four or five old guys—old farmers and steam-engine operators" gathered around one of his paintings, engaged in spirited reminiscence.

He did some commissions for area residents of their farms and favorite places. He claimed to have painted 100 pictures. He signed his paintings with various versions of "Franklin Halverson," "F. Halverson," or just "Halverson." Later in life, as his handwriting got shaky, he used a stamp, imprinting his name in a script type. Some of his pieces also include, on the back, a fingerprint. While some paintings were done on pre-stretched canvas, many were done on masonite.

Through the efforts of friends and some newspaper articles, he began to achieve local recognition. Neighbor Richard Burr was a member of the Board of Supervisors for Buena Vista County and convinced Franklin to donate several paintings to hang permanently in the new courthouse in nearby Storm Lake.

In 1977, Franklin entered a competition to purchase artwork for the new State of Iowa's Wallace Agriculture Building in Des Moines. "I think I aged three years in the three months it took them to decide," he told Michele Mickelson. One of his favorite scenes, "Threshing," was chosen and hung there for many years.

An active member of the First Lutheran Church of Sioux Rapids, he did drawings and design work for a new church

building, of which he was very proud.

A distinguished-looking gentleman, he was described as being very modest, but a good conversationalist with a dry sense of humor. Everyone who knew him enjoyed his friendship very much.

When his sister Clara passed away, Franklin, then in his eighties, found it difficult to live alone. He also realized his dream of a museum of his paintings was not likely to happen soon. He decided to put his paintings up for sale. While there was no official announcement, the word spread quickly and friends and neighbors hurried over to pick out favorite scenes. Within a short time, the paintings were hanging in homes around the area, treasured for their local flavor and as memories of personal friendships with the artist.

He entered the Sioux Rapids Care Center in July 1985. In the nursing home, Franklin was still very active and tried to organize events like a reading society to meet out at his home farm. He passed away on April 7, 1989, at the age of 96 years.

Franklin was a man who, in a quiet way, was very proud of his life experiences and family heritage. Never one to brag, he methodically created a remarkable body of work which documented, with the eye of a draftsman, the life of the Iowa prairie farm of his youth.

• • •

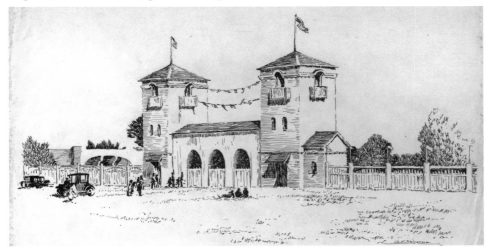

*"I always liked the springtime best. So I asked my father what season he liked best, and he said, 'The autumn... 'cause that's when I get paid.' "*

Bob Barnard

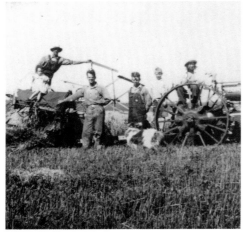

The Barnard family and hired man cutting oats, 1937. Bob is in center wearing overalls, with collie dog. His dad is standing on binder.

Bob Barnard with his prize steer which he showed at the Clay County fair, 1930.

Bob Barnard, author of the companion stories, was born in 1920 in Spencer, Iowa. His father's farm was just outside Gillett Grove, a small village in Clay County. Spencer was about fifteen miles to the northwest and Sioux Rapids equidistant to the southwest. Gillett Grove had a post office, bank, general store, blacksmith shop, hardware store, and a few other amenities.

Bob's parents, Charles and Helen Kunath Barnard, farmed a 200-acre prairie farm. It was a typically diversified operation. They raised hogs, milked a dozen cows, kept a few hundred chickens. The family raised sheep to sell wool, and kept ducks. Charles Barnard planted corn and oats, with a little barley mixed in to make good feed. He had some sweet-clover pasture and grew five or six acres of potatoes as a cash crop.

Charles also took care of some additional land owned by his mother. Scattered here and there across the prairie and river bottoms, these holdings had been purchased by Bob's grandfather, a banker and newspaper owner. He passed away when his son Charles was just nine years old, leaving his wife with three sons to raise. As her sons grew up, she was able to give them each a farm. Charles got his when he married in 1916; on the deed was written in his mother's hand, "With Love."

Charles and Helen had five children, with Bob right in the middle. As Bob grew up in the 1920s and 1930s, the farm was still worked with horse-power. His father kept five or six draft horses, allowing him to put together two or three teams. Not until 1937 did Bob's father get his first tractor, an International Farmall. However, some farmers in the neighborhood were using tractors by the mid- to late-1920s.

Young Bob never met his Grandpa Barnard. He spent more time with Grandpa Kunath, his mother's father. Herman Kunath was a jeweler in Spencer. He was known as the Dancing Jeweler because of his love of music and dance, whether at barn dance or ballroom. Herman and his daughters, Bob's mother and aunts, were known as a fun-loving, musical, high-spirited family that liked to get together and socialize. It was at these family gatherings that Bob heard many tales of older ways of farming.

Growing up on a farm "instilled a sense of freedom" in young Bob. Like his father, young Bob was a standout in baseball and basketball. He won awards in declamatory contests and took part in school plays. Graduating in 1938, he worked for a while on his father's farm.

Like Franklin Halverson, Bob Barnard was swept into a world war which took him far from the prairie farms of northwest Iowa. In 1939, Bob joined the U.S. Air Force. By early 1941, he was part of the crew of a new B-17 bomber en route

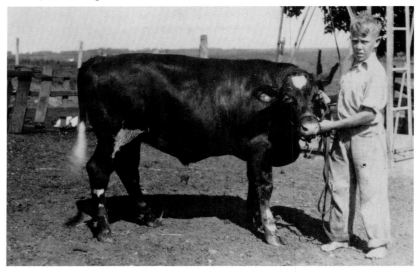

across the Pacific to its first post. Fourteen hours later, on December 7, their plane arrived at Pearl Harbor, Oahu, to discover they were trying to land in the middle of the surprise Japanese air strike in progress. The harbor was in flames and Japanese fighters were everywhere. One member of Bob's crew, who had been stationed there before, knew a small fighter strip away from the main base where they set down safely.

Barnard survived that first combat and another 66 missions on the Pacific Front. He returned to the States to be married to Ruth Jespersen, daughter of farmers Henry and Martha Jespersen from the Danish-American area of Royal, Iowa. After Bob's discharge from the service in 1945, he and Ruth took up residence on the farm next to Bob's parents and tried to make a go of it.

It was hard. As Bob said, "That farm never grew very good for me." A rented farm, it had seen hard use by tenants. Unlike his father's farm just across the road, very little had been put back into the soil over many years. Bob and Ruth milked fourteen cows, using a milking machine. They raised 100 to 125 hogs and 400 to 500 chickens. They grew corn, beans, and some oats. Less oats were needed as feed for horses, as Bob was farming with a tractor, a Minneapolis-Moline.

In those days, almost everyone agreed that farming with tractors "was the only way to go." Still, "it put a lot of pressure on everyone. Instead of working less, everyone just went out and tried to farm more land." More wetlands were drained by tiling, and, as Bob said, "The squeeze was on. You had to work harder just to keep up and not go broke. If you did,

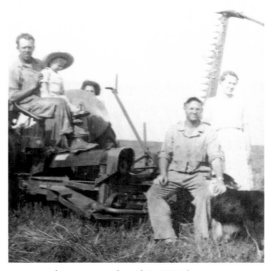

Bob Barnard, on tractor, gets help mowing hay from brother Charles, Jr. (on right) and neighbors, 1948.

someone was waiting, eager to buy your land." With tractors, farmers were focusing more on crop-farming. It was becoming less economical to keep animals, unless you specialized and kept large numbers.

Bob remembers getting back from the service, and seeing his father picking corn with a tractor, and his father saying, "It was getting pretty hard to look a horse in the face anymore."

Bob and Ruth farmed for seven years, six years by themselves and one year helping his father on the family farm. Then Bob took a job selling fertilizers and livestock feed for almost thirty years. In 1982 he retired to live in a lake district to the north of Clay County, in the town of Spirit Lake in Dickinson County. He still works part-time, writes, and participates with his wife in local musical theater and chorales.

The Barnard family farm, 1937.

•••

The paintings in *A Time to Harvest* depict a period roughly from 1900 to 1920. This was an era of farming with horses, just prior to the arrival of the gasoline tractor on the farm. Bob Barnard's stories reflect on that period, using accounts heard from elder farmers, blended with his own memories growing up on a farm worked with horses until 1937. Bob also recalls images from the Depression years of the 1930s, when gas and new equipment was expensive and farm families often returned temporarily to older methods of farming.

Importantly, the lives of these two farmers intersect in the 1920s and 1930s. This was a watershed period for American agriculture. In just a few decades, farmers switched from small-scale, diversified farming, using horses and handwork, to the mechanized, tractor-powered, specialized farming that has dominated from the mid-1940s to today.

Why did Franklin choose to document a pre-tractor era? He himself farmed into the 1940s, using both a team of horses and a small tractor. Continuing to live on his family farm, he saw it farmed successfully with tractors. Like most of his neighbors, he probably accepted technological changes as progress. In fact, drawing new designs for equipment manufacturers was his paid employment for many years. Was there a bittersweet nostalgia in his paintings of an older time, or was he just determined to record a disappearing era he knew so well?

Like many documentary artists, Franklin was clearly

Large hitches of horses or mules were used for heavy work like plowing fields or grading roads.

Dairy cattle take a break from the summer heat in the Little Sioux River, 1910.

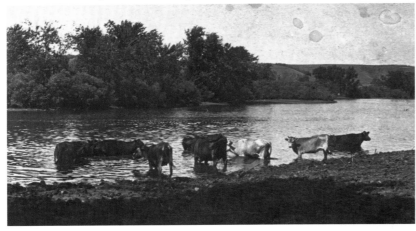

interested in the technical side of the past. He sought to render the equipment and practices of the pre-tractor era in accurate detail. Interested in history, he must have viewed documentation as valuable for its own sake, to teach young people about bygone ways or help old-timers recall their own experiences.

In common with other memory artists, Halverson's paintings often illustrate a certain ideal view of how a particular activity was *supposed* to be done. In Franklin's paintings, the weather is pleasant, the machinery well-oiled, the buildings in good repair. The animals and people are in robust health, the crops in full ripeness. Everything seems to be going as planned.

Halverson chose not to illustrate that which did not work—the faulty design, bad weather, the sick animal, the mechanical breakdown when everyone stood around waiting for hours. Not shown are neighborhood arguments about fence maintenance, borrowed and damaged equipment, animals that got loose, insults real or imagined.

Memory paintings rarely speak to the worst cases: tragic accidents when fingers were severed by machinery, an overloaded wagon tumbled, or a runaway team resulted in catastrophe. As with other memory painters, Halverson's goal is to show the positive side of life.

Clearly, these paintings are not documents of actual events but models of how things were supposed to work. Like all farmers, Halverson knew that things did not always go as planned. He sought to document the "right way" to do a task. Any farmer could then compare it easily to his own experience.

Franklin does show a sense of the small moments often overlooked in visual documents of farming traditions. In

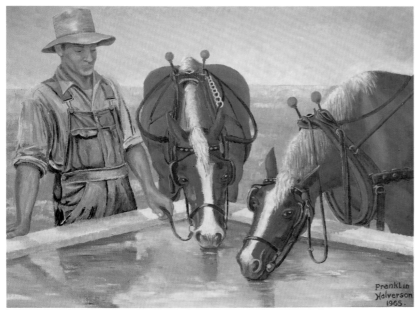

"Quitting Time," the day's work is done. The horses are being let loose, the sun is setting, and a peaceful mood reigns. In "A Rainy Day," two boys get an unexpected, magical break from work due to a rain shower, and seize a chance to lie in the haymow, to talk and dream. These are moments rarely captured by painting or photograph.

Franklin Halverson's experience as a commercial artist for farm-equipment manufacturers was important training. The job demanded drawings that showed how and why something would work well. His catalogue illustrations and magazine advertisements were supposed to help sell equipment to cautious, cash-poor farmers. The ideal image of the smoothly-running piece of farm equipment, the flawless field operation, was central to the business of convincing farmers to modernize.

Yet Halverson chose in his paintings to document an earlier time. Showing a somewhat idealized view of the past, these paintings might seem to romanticize the "good old days." Yet farmers have the practical knowledge to understand the difference between valuing the past of farming and living with its present condition. Today, most commercial farmers use tractors and view farming with horses as unrealistic, without a religious commitment like that practiced by the Amish. Yet many old-timers would agree it got hard to see their abandoned partners and "look a horse in the face."

All farmers will understand the values seen in Halverson's paintings. Country schools and threshing runs stand for an era of neighborhood cooperation. The scenes recall vigor in the youth of elders. They celebrate the bounty of the harvest at its fullest. They invoke a time perceived to be rich in human closeness, in self-sufficiency, in simpler technology. These ideals were not always perfectly achieved, but were cherished values nonetheless.

Draft horses were hard-working, faithful participants in the farm operations of the early 1900s. From Halverson painting, "High Noon," 1965.

Early field tractors had limited ability. Here, a tractor and two teams of horses work together to cut corn.

• • •

Franklin Halverson's paintings may show blue skies and successful operations. Bob Barnard's stories, however, dig a little deeper in the human experience. While explaining the ideal operation, they also touch on the occasional mishap: the team that got stuck, the wagon that was late, the boys that got scolded, the calf that almost died. These are stories based on oral traditions, tales shared with his family and with other farmers.

Traditions of talking—story-telling, reminiscing, or joking—explore the opposite of the ideal. They chew on the memorable incident, the individual opinion, the odd or humorous occasion.

It is easy to picture four or five old-timers, standing in front of one of Halverson's paintings, recalling memorable episodes. Such memories explore the endless variety of life's events. Fact and fiction may cross freely, the truth stretched on occasion to bolster the point of an entertaining story. Reminiscing reveals different information than does a painting of a perfectly-done fieldwork task.

These two ways of recalling the past—the ideal image and the reminiscence—are very different. The ideal image documents what farmers *hoped* would happen. The reminiscence explores, within the general boundaries of what *did* happen, what they *choose* to recall, share, and celebrate.

Both—the ideal image and the anecdote—touch on the essence of what leads farmers to farm. Although they know things may not go as planned, they still hope for the best. If something does go wrong, the story afterwards helps to teach, correct, and heal, often with laughter. Remembering, in many settings and forms, gives farmers the strength to continue planting seeds, to watch the skies, plan their harvests, and hold tight to their values.

• • •

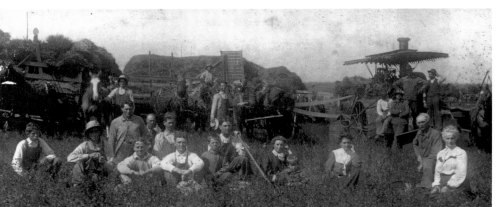

This book, then, documents perhaps only one place, a rural region in a corner of Iowa, in the experience of two farmers. Yet all farmers can look on these scenes and see the truth in them. Telling about one place and one time, they speak of thousands upon thousands of families scattered across the Midwest, each with their patterns of planting and reaping, working and socializing, remembering and celebrating.

The title, *A Time to Harvest*, refers most prosaically to a farmer's calculations that the grain was ripe enough. It also holds a symbolic message for the rest of us. If such rich images, planted across the country, are now ripe in the recollections of old-timers and the living ways of the family farm, perhaps it is time to harvest those memories. Perhaps we need to thresh their essential best, to bake a bread of heartfelt values, to pass this bread around our common table.

If this meal of recollection tastes good, why? Perhaps there is something in the folklife of the family farm to protect and preserve. Perhaps we do not even know exactly what part is most important to each of us. Are we interested in issues of family values, in historic ways, in land stewardship? The threads of human tradition and heritage run through all those. The intangibles of cultural folkways and skilled memories are as precious, one might argue, as the historic building or endangered species of animal or plant life we are better trained to appreciate and protect.

Conservation of culture—finding a way to preserve its essential goodness—is a challenging task. What makes a

culture healthy? What is important to save and encourage? What does a healthy culture do for us? As poet, essayist, and farmer Wendell Berry describes in his 1977 book, *The Unsettling of America: Culture and Agriculture*:

> *A culture is not a collection of relics or ornaments, but a practical necessity.... A healthy culture is a communal order of memory, insight, value, work, conviviality, reverence, aspiration. It reveals human necessities and the human limits. It clarifies our inescapable bonds to the earth and to each other. It assures that the necessary restraints are observed, that the necessary work is done, and that it is done well. A healthy **farm** culture... nourishes and safeguards a human intelligence of the earth that no amount of technology can satisfactorily replace.*

A few pages later, he points out the dangers of a gradual loss of cultural knowledge:

> *[Restoring cultural loss] is uphill, and it is difficult. It cannot be fully accomplished in a generation. It will probably require several generations—enough to establish complex local cultures with strong communal memories and traditions of care.*

Anyone involved in preserving the prairies which Halverson's forebears mostly plowed under and replaced with farms will understand the challenge of trying to restore a complex natural community like a prairie. Likewise, cultural conservation is difficult. How *does* traditional farming protect and nourish a "human intelligence of the earth"? How *can* we preserve the rich variety of traditional values and folkways, interwoven by generations of family and neighborly heritage in a place like a prairie farm?

How are we ourselves joined, in a web we may not see, to these memories of farming in "the most beautiful country ever beheld," a common place in the heartland of the Midwest?

◆ ◆ ◆

If you are drawn into these paintings and stories, perhaps Franklin Halverson's original dream of a museum will be realized. Instead of a physical site where his paintings are collected, this book can be a "museum without walls," carrying his vision to you. I hope it gives you something to look at, to enjoy, and to think about... in your own homeplace, wherever that is.

Special thanks to many from near and far who helped with this project. A list of acknowledgments is given in the last pages of this book, with some selected resources and readings.

Philip Martin
Midwest Traditions, Inc.

Franklin Halverson's paintings, done in his sixties and seventies, documented the life of the prairie farm of his youth.

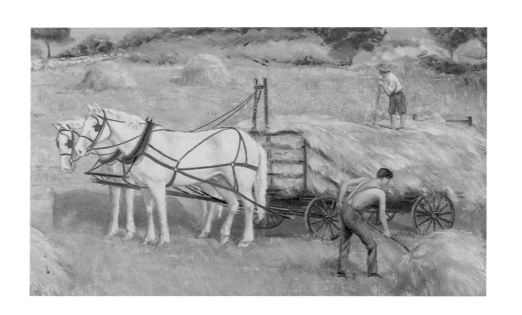

# Summer on the Farm

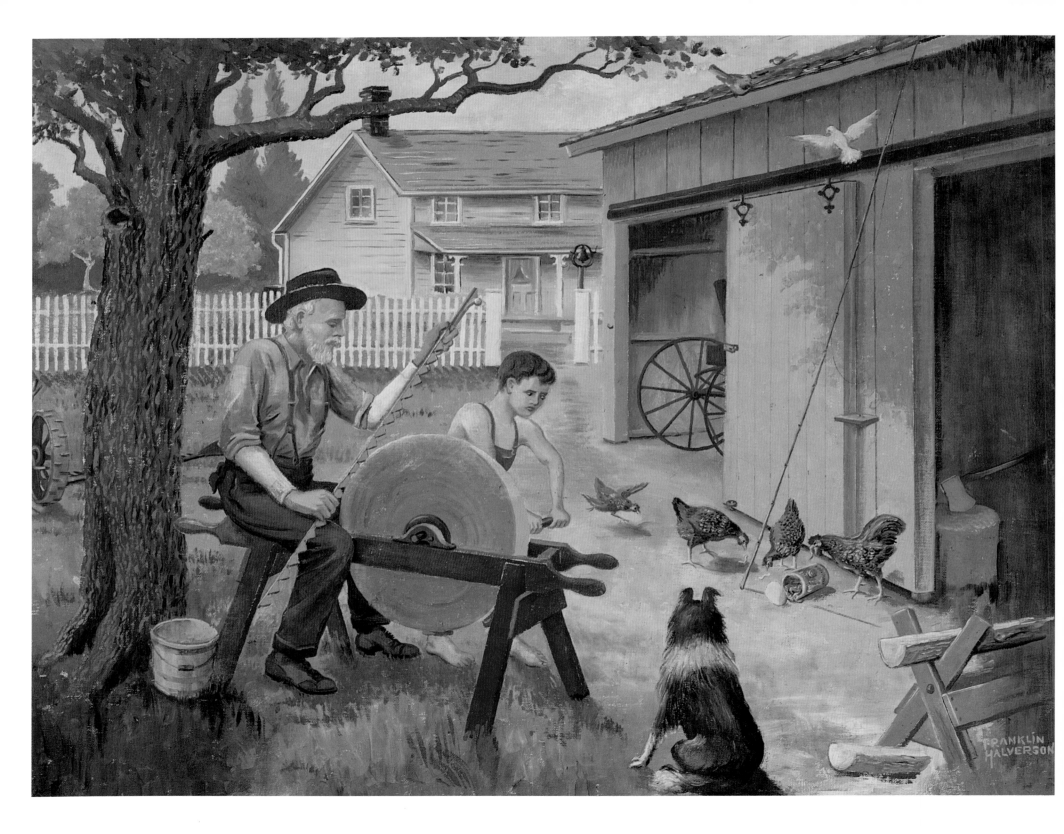

# Vacation at Grandpa's

On almost any farm in late May you could hear the gentle hiss, like water simmering in a kettle on the stove. With sleeves rolled up, knees dampened from splashing water, Grandpa sharpens a mower sickle on a smooth sandstone wheel turned by his young helper. A half-bucket of water sits close at hand to cool the blade. Getting the big mower blade ready to cut hay was a task that required great concentration and two pairs of hands.

Haying season came in late May and early June, between corn planting and cultivating. If for any reason haying was delayed, a farmer might not be able to cultivate his corn at the right time. The cornfield would get grassy and hard to work. Therefore, all haying machinery had to be in top shape so the farmer could get the job done quickly. Everything had to be timed just right. Keeping the mower blade sharp was important.

Above the steady hiss of the stone, you could hear a rooster crow. A hen cackled about the fresh clutch of eggs she has brought into the world. Pigeons strut, cooing softly, seeking their mates for the summer. The white-collared dog sits and pants, quietly waiting for the job's completion, hoping his faithful companion will help find some pesky gophers to dig out or a rabbit to chase.

In front of the sliding shed door, an open can has been knocked over and its contents are beginning to escape. It's a can of worms, placed at the foot of the long fishing-pole. The poultry have discov-

ered the can, and probably tipped it over. A rooster has captured one, and the rest of the flock is showing great interest. Intent in studying the sharpness of a sawtooth, Grandpa hasn't noticed the nearby accident, and the young fellow dares not leave his post. His job is to keep the heavy wheel turning at a steady pace.

It seems that the plan, after the sharpening was done, was to go fishing. May is not only haying time, it is also the month when the bullheads start biting. Bullhead fishing was an exciting way to kick off a boy's summer. The river wasn't very far from the farm. With a slender cane pole, some worms for bait, and a dog for a companion, this youngster's vacation at Grandpa's is off to a good start.

A gnarled box-elder tree stands solidly, a silent watchman, with leaves sheltering Grandpa and helper at their task. Nearly every farm had a grove of box-elders. These sturdy, fast-growing trees gave good shade and windbreak. They had a short life span, so other trees were often planted to replace the box-elders as they died out.

The scene depicts a moment in the life of a farmstead obedient to the season of spring. Grandpa and his young friend sit together in quiet harmony, preparing for the work of haying, anticipating the pleasure of fishing. The white picket fence, straight and brightly-painted, stretches out from two entry pillars, enclosing the yard. The soft yellow of the house conveys a warm welcome. An old school-bell rests in its iron support, ready later in the day to invite all hands to dinner.

# Schoolyard Fun

With hitch-rail in front and plenty of yard for the kids to play in, this is a scene typical of a one-room school in the country. A solitary horse stands quietly, eating the lush spring grass that flourished on schoolyards. Some yards had a lean-to or shack to protect horses in the winter cold. Otherwise, a halter rope was tied to a stake in the ground so the horse could graze. Most youngsters that rode horses to school went bareback. A saddle was too cumbersome. It just took too long to get going in the morning.

The girls are having fun on their own, playing 'Ring Around the Rosie.' Behind them, an entrance to a storm cave shows in the side of the hill. This shelter was built with heavy timbers, then covered with a foot or two of black soil. The wide opening allowed easy access if the kids needed to hurry to get away from high wind or a twister, spotted swirling across the rolling prairie toward the school house.

Periodically, we had emergency tornado drills. We all filed out the door and marched to the storm cave. Stepping down into the clammy recess of the cellar, we sat on two long benches on either side of the small tunnel, facing each other, until our teacher gave us the "all clear" signal and led us back to our lessons.

The foreground depicts an activity the boys all knew well. A group of young students prepares to snare a gopher. One boy has the snare encircling the hole. The curly-headed boy will pour water down the hole until the gopher pops his head out. Then the boy with the string pulls it quickly, cinching the noose around the gopher's neck.

We preferred a heavy yellow fish-cord that would slip easily. Most teachers were reluctant to let the boys indulge in this pastime during school hours because the little rodents are tenacious fighters when they get cornered.

Every schoolyard had several families of striped gophers, constantly whistling warnings and calling to their mates. These little hoarders were an enemy to the farmer. They damaged crops, nibbled vegetables, and stole seed. They could honeycomb a hill with their digging and burrowing. Their holes were a danger when horseback riding. To us, the striped gophers were pesky rodents, and we hunted them avidly.

The small blonde boy holding a baseball seems to think a baseball game would be more exciting. Likewise, the boy with the bonnet straw hat, reclining on the grass with a slingshot in his hip pocket, is nonchalant. He is the only one of the group that is wearing shoes. All of the boys wear jeans and loose-fitting shirts. Fancy dress with knickers, long stockings, and tight jackets was reserved for Sunday.

For his part, the collie dog is showing plenty of interest. He's ready to give chase if the gopher manages to slip through the snare.

Maybe the fellow with the straw hat knows the hunt is over, because he sees the teacher ringing the bell. Recess is over.

◆◆◆

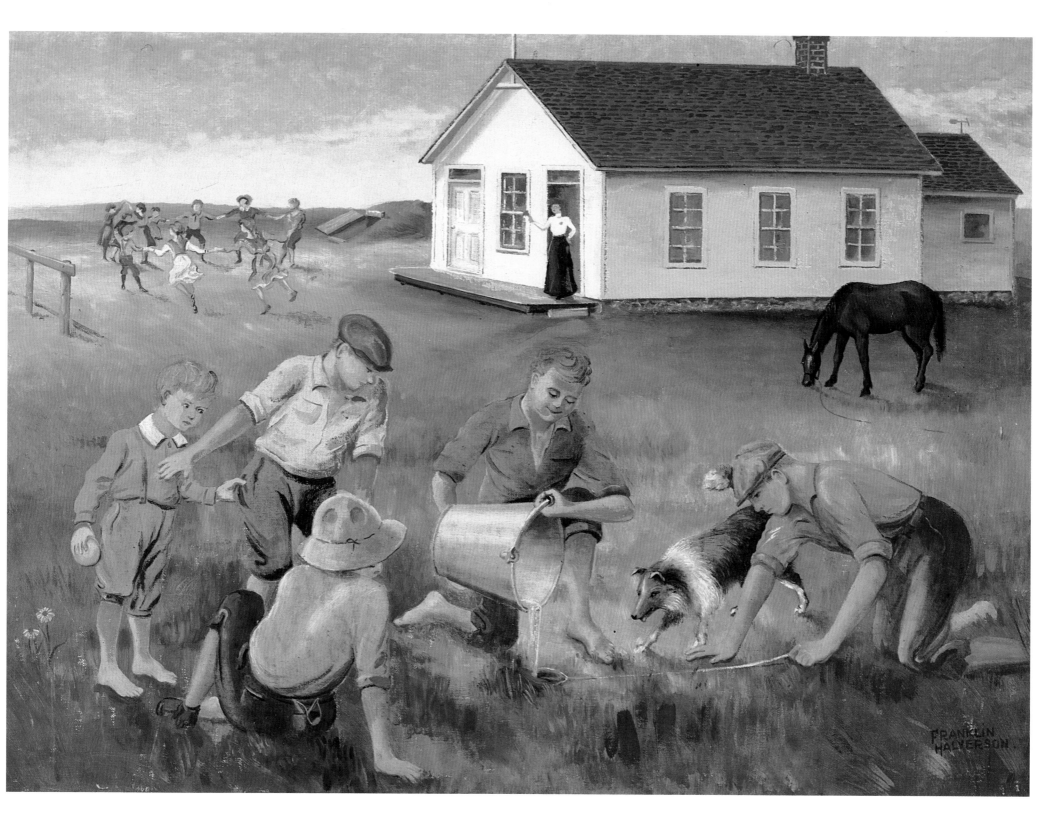

This picture brings to mind one hot afternoon back in the 1920s. Two boys got to leave behind the hum and hiss of a threshing machine to drive a big wagon of oats all the way to the grain elevator in town, a couple of miles away. I was excited. I was only seven, while my older companion was fifteen.

The three-tiered wagon was full of warm, freshly-threshed oats. Our instructions were to "hurry back," because we had the only extra wagon. If we didn't get back in time, they'd have to shut the threshing machine down.

As the horses plodded along, my older friend uncoiled a length of yellow cord and tied a noose on one end. He coiled it up again and slipped it back in his shirt pocket. At the elevator he picked up the necessary receipts and we headed back to the threshing rig at a fast trot. But the day was too hot, and we slowed the horses to a relaxing walk.

We passed a large bluegrass pasture and heard the gophers' whistle. A meadowlark's distinguished call echoed over the field. My friend decided the horses needed a rest.

Gophers scurried and whistled as they disappeared into their maze of dens. Quickly, my friend slipped the noose around an entrance. After gophers first disappear into their holes, they generally come right back out to check what frightened them. That's why you have to be quick to get the noose around the entrance.

I was lying flat on my stomach, watching the hole as directed. Suddenly, my friend pulled on his string and a striped gopher fought desperately to get free from the noose. The little animal pranced and jumped, then quieted and whistled, exhausted from the tight noose.

My friend pulled another noose from his pocket, handed me the first string with the gopher to hold, and quickly slipped a noose around another den. With a quick pull, he had a second catch.

We were wasting time. He loosened both nooses and released the animals, and we ran back to the wagon and started the horses at a trot.

At the machine we got hard looks. His father complained that to make room to continue threshing, they had to tramp down one load of oats and scoop another onto the ground. We were both treated as outcasts for the rest of the day.

◆◆◆

Most country-school districts were no bigger than townships. Each school was run by a board of trustees or directors, usually only three people. They hired the teachers. Teachers' pay was meager, as were farmers' resources. One trustee was designated to write the checks to pay the bills and the teacher. Thirty dollars a month was considered reasonable.

The teacher usually roomed close by the schoolhouse with a family of one of the students. Often the teachers were young, single women, fresh from teacher training programs. Sometimes they were not much older than the eldest students.

Dedication and discipline were the keys to the method used to teach the "three Rs" — reading, 'riting, and 'rithmatic — through the eight grades. Our schools had names like Rainbow Number Seven, Logan Center, Harmony, Hopewell, District Number Eight, and Willow Grove. Each had a potbellied stove for heat, and it was a job of the trustees to see that plenty of firewood was stacked away for the winter. In the farming year, the schoolhouse wood was cut and stacked between silo-filling and corn-picking time in the fall.

It was left to our parents to determine how we would get to school. In cold weather, we came in buggies and wagons. When the snow got deep, bobsleds and cutters worked the best. The majority of the kids walked most of the time, except in frigid cold weather, and stayed home only when temperatures reached zero and below.

# Summer Pasture

On a bright, damp summer morning a farmer drives his triple-box wagon, squeaking and rattling, through a beautiful scrub-timber area looking for a newborn calf. The calf was dropped in the early evening of the night before. When the farmer finds it, he will bring it to the barn and make sure it's healthy, and the mother will become part of the milking herd.

A heifer's first calf releases her instincts to hide her calf from predators. It was a challenge to the farmer — especially one who had terrain like this, in valleys and draws — to find the newborn. If it was a normal birth and the calf got a good first drink of milk, it might stay quiet for a long time and not bawl. The farmer would have to stop his wagon frequently to get out and search every nook and cranny of the area.

A farm dog, however, could use its nose to help the farmer quickly discover where the cow dropped her calf. On seeing the dog, the cow would run straight to her calf, bawling and making a fuss.

Most farms, especially those with livestock, had a dog. In his realm, the dog was king. He knew which livestock should always be behind certain fences and he would create a real ruckus if they strayed from their boundaries. At night, this canine vigilance was appreciated by the farmer who would be alerted if the stock somehow got out.

For a kid, a dog was a best pal. Especially on cold winter nights, it was heart-rending for me to leave my best friend outside when the talk at mealtime was of how cold it would be that night. If you let him in, however, his gratefulness overcame all common sense as he wagged his tail, beating you on the back of the legs, banging against chairs and tables. The trick was to hustle him off to your bedroom, unseen by either parent, with plans to let him out early next morning before the folks got up. Old Pal's tail-wagging ceased only when he crawled on the bed, and I got him under the covers and started petting him. I was sure he wouldn't disappoint me in this little act of subterfuge.

Dogs were sometimes given free, and sometimes sold, traded, and bartered for. A valuable farm dog had to be a "heeler." This meant that when sent to retrieve a wayward critter headed for an open gate, the dog nipped at the animal's heels and turned the animal back into the yard. If, on the other hand, the dog went for the animal's head, the result was unpredictable, possibly causing more problems than the dog was worth.

A strange fact sworn to by the old-timers was that if a puppy was

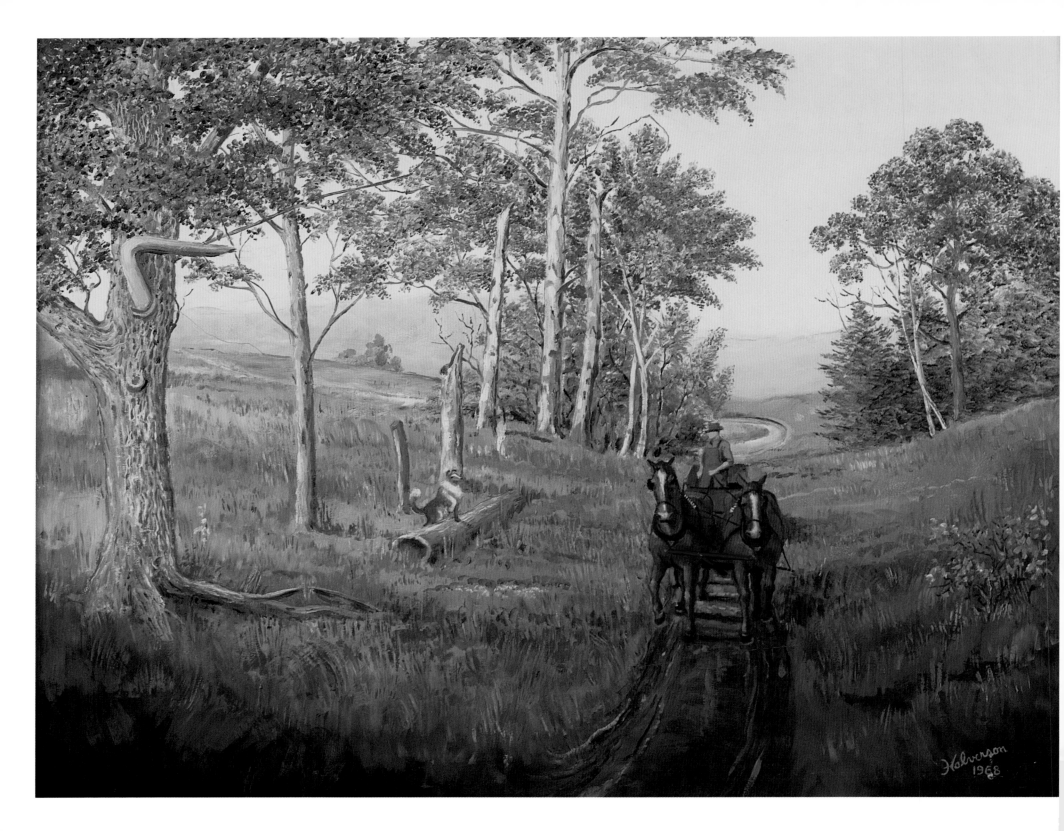

observed getting his daily meals from a hind teat of his mother, the dog would turn out to be a heeler. Many were so convinced this phenomenon was true they wouldn't take any other dog in the litter. The theory was that, if the infant dog's inbred habit was always to go to the hind teat, later in life he naturally would go to the heels of any critter being herded.

This kind of dog was a tremendous asset to a livestock farmer. My dog, old Pal, was a farm dog whose instincts steered him to the heels... only if the critter cooperated by keeping his head on the right end. Sometimes the critter's head was simply misplaced and Pal was unfairly ostracized, I argued, for chasing the wrong part.

◆ ◆ ◆

Most farmers carefully planned to have all calves born by August, or early September at the latest. The nights cool off by late August and we can get frosts in late September. A calf dropped away from the buildings in freezing weather has a good chance of not making it. My father had a little book with a description of each cow, recording when they were bred and when they were due to calf. But if he bought a good-looking milk cow at a sale, he had to count on a promise she was "due to calf in the summer."

My father made a mistake once, I recall, in the mid-1920s. It was late October and the nights were cold, freezing nearly every night. My father didn't think the cow would leave the dry, accessible comfort of a large straw pile left especially for her. My dad didn't check the cow at bedtime because she wasn't showing any signs of nervousness and was eating peacefully when he milked and cared for the other livestock. But she crawled through a woven-wire fence and headed for a cold, lonesome part of the farm. It turned out to be one of the few nights the dog was let inside all night.

Following her path easily in new snow the next morning, Dad tracked her and found a newborn calf, nearly dead, lying sprawled out in the cold. He carried the calf to his wagon and headed straight for the house. Mother met him at the door. He quickly carried the newborn to our basement where a warm fire crackled, and he laid the calf carefully on some rugs. The cow had followed the wagon back to the barnyard. Dad put her in her stanchion, milked a couple quarts, and headed back to the house. By now, the calf had responded and was on its feet.

The calf's head was held up. Father poured two ounces of brandy down its throat, then repeated the procedure with fresh milk from the mother cow. Soon after, the sleek new calf was kicking up its heals.

From then on he watched his cows more carefully, and bought milk cows only from people who knew when they would calf.

# High Noon

After a long morning in the field, two Belgian horses quench their thirst at the stock tank. These big, gentle Belgians were hard-working, faithful partners in many farming operations. They were used to pull plows and other heavy implements that required great strength.

Few of us who grew up on a farm will forget their first ride on the back of one of these magnificent animals. Mine was on a huge, solid brown with a glossy black mane. He was a cross between a Clydesdale and Belgian, with the Clydesdale's big feet and feathered fetlocks. His name was Prince.

I was about five years old. At the noon break, I loved to run and watch my father unhitch Prince and Beauty from the single-row corn cultivator. I was full of questions. One of them was always, "Can I ride Prince to the barn?" But my father would never let me.

Then, one day, he grabbed me under the arms and gently lifted me up to sit behind the hames and collar. The hames are the yellow round balls sticking up from the collar to which the harness tugs were attached.

As we headed for the stock tank, Prince's long determined strides and pumping head frightened me. To make matters worse, the heavy harness straps pinched my short legs. Mindless of me, Prince ambled toward his drink, knowing a feedbox full of oats awaited in the barn.

My fright increased when the horse got to the tank and stretched his long neck far out to drink the cool, sweet water in the middle of the tank. Nothing was going to get him away until his thirst was satisfied. Too frightened to scream, I just held on.

At last, Prince brought his head up, and the harness pinched again. I think for the first time he realized I was there. Without warning, he shook himself, like a wet dog will do, pumped his head again and headed for the barn. Finally, my father grabbed me and this was my deliverance.

◆ ◆ ◆

Years later, my father decided to replace our old worn-out cultivator. He bought a new McCormick Deering single-row, and I learned its use. I was sixteen. It was red, and it made me very proud to be the one to use it.

A single-row cultivator has two "gangs." Three shovels on each gang glide through the soil on either side of the row of corn. The blades roll dirt in toward the corn, covering weeds. The operator has two control arms, one to guide each gang. A good operator with a smart team and cooperative soil can roll dirt right up to the base of the corn.

When I came to the end of each row, to make the turn back, I stopped and lifted the gangs upright out of the ground to hooks bolted on the frame. As I started the next row, I dropped them again and the cultivating continued.

Our faithful workhorses were so docile, they responded to the lightest pull and to voice commands. I loved those horses! Since I had both hands on the control arms guiding the gangs, the reins were draped around my back. I drove the team mostly by squirming and leaning.

On the new cultivator, one shovel protruded outside of the wheel when the gangs were raised. If you walked too close on either side of the cultivator, you could skin a shin. After a long, windy day of cultivating corn, I unhitched old Prince and his mate, Beauty. As Beauty came around, too close to the wheel and too late for me to stop her, her right harness-tug caught on a shovel.

Frightened, she took off, dragging the cultivator sideways almost all the way to the barn, one hundred yards away. As the harness broke loose she stumbled, and it frightened her more. She headed down the road, with old Prince faithfully clomping along behind her, away from all the hurt.

I got them turned back to the barn, with part of Beauty's harness dragging in the gravel. I was afraid the cultivator had scraped her leg as it rolled and bounced. Both horses were nearly exhausted but luckily neither was hurt. But the cultivator never worked quite right again.

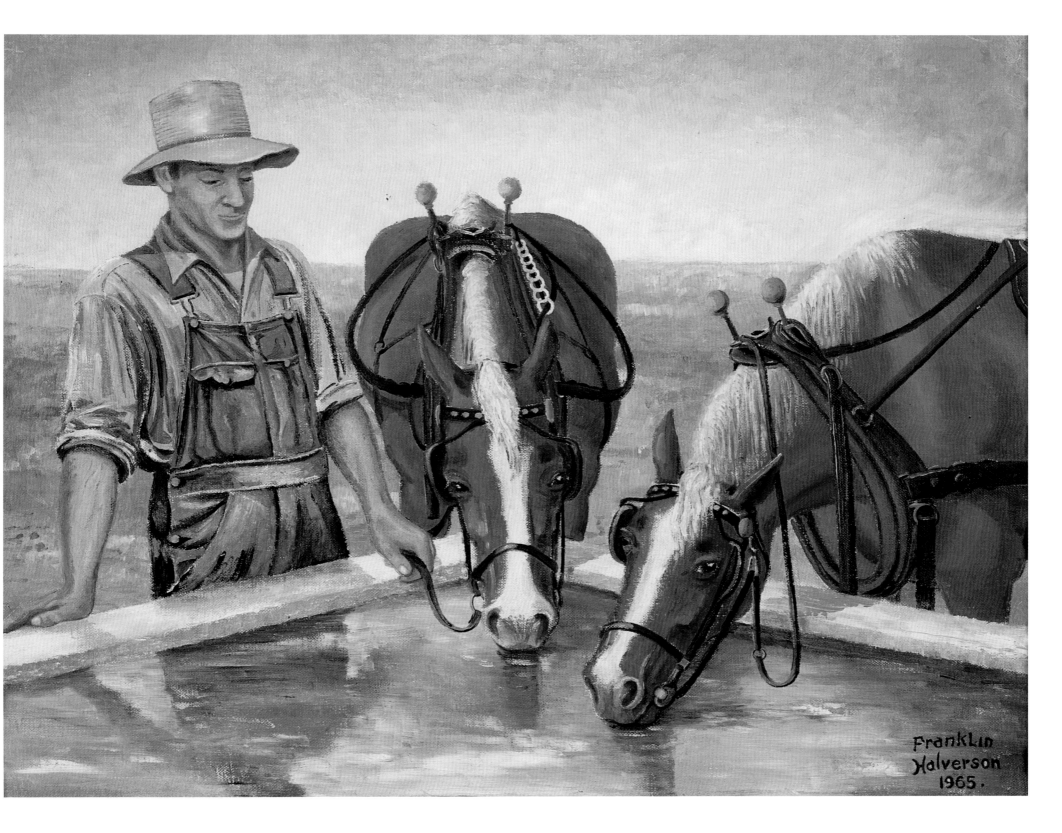

Franklin
Halverson
1965.

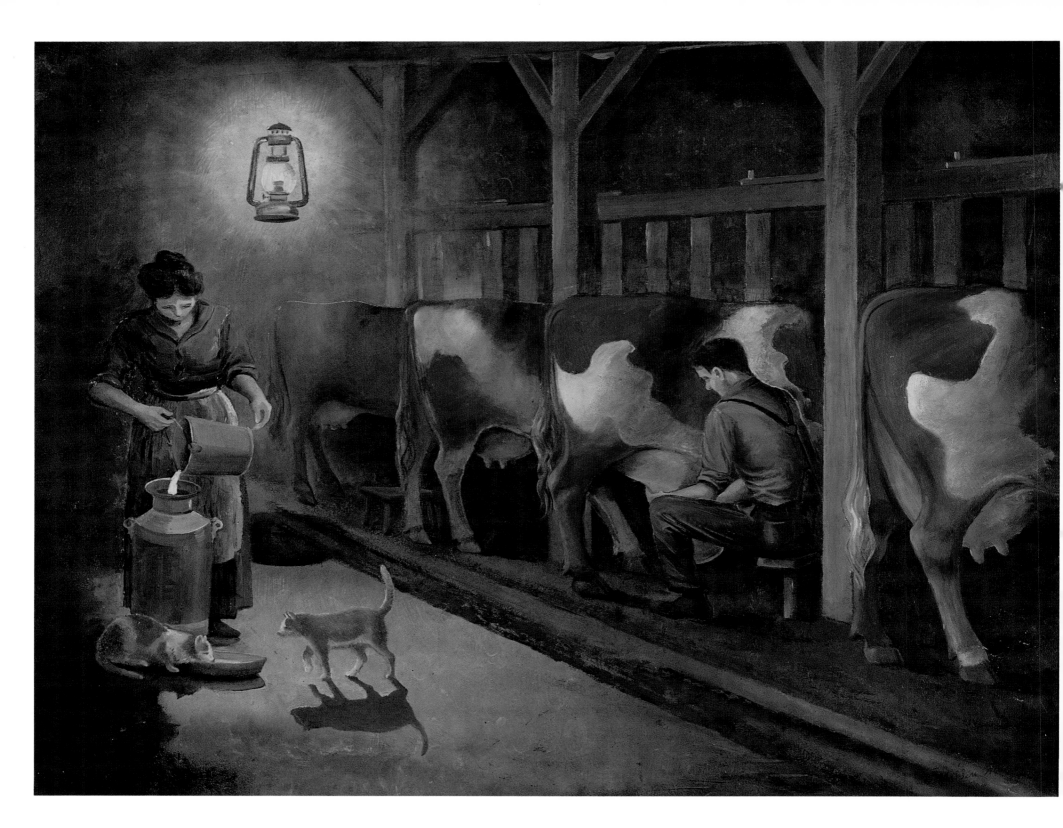

# Milking Time

Wooden stanchions and brace-posts cast eerie shadows around a family milking operation. A husband and wife complete their day's labors. After working around the farm all day, they are milking a small herd of cows. Above, heavy crossbeams support the hayloft where soon a new crop of summer hay will be stored.

The hanging lantern gives barely enough light. Bare-headed and sleeves rolled up, the couple is dressed in summer clothes. The darkness means either they worked late in the field, or they purposely waited for darkness to avoid pesky flies. In July, flies could be unbearable during daytime hours. It was a grim proposition if a cow, trying to get rid of a fly, kicked over a valuable bucket of milk. Before the arrival of fly spray, small family operations like this often milked late each evening and early each morning. Having only a dim lantern might help keep the flies away too.

The man has a one-legged stool, while the lady uses a four-legged variety. The one-legged stool was the most common. It was handy, easy to store when not in use, and easy to repair. The lady hasn't picked up her stool yet. Most cows I knew and milked wouldn't have tolerated an empty stool left around their feet, especially while they were eating.

Milk herds generally had a pecking order. No upstart young heifer would dare cross one of the old Grandmas that ruled the barnyard. It didn't take long for a frisky heifer to learn, because the old cow would come storming after her. Heads would clash, and the youngster would find she had no help from others in the herd. The old cow was usually heavier, with more experience, giving her a clear advantage.

The cows were often enticed into their stanchions with a couple ears of corn or a half-gallon of oats in the feed trough. By habit, each cow usually headed straight into her favorite stanchion. While they munched away, the milking was done. Since it is summertime, after being milked they will be turned out again to graze all night in some lush, green pasture, without a worry about flies until morning.

With their soft fawn-colored coats patched with white, most of these cows look like Guernseys. This breed, first brought to America in 1831 from the British Isle of Guernsey, produces milk with a rich butterfat content.

The lady has just finished milking the cow on the far end. This cow looks different. Of smaller build, with a smaller udder and a dark-fawn color, she could be a Jersey cow. Ladies often had their own particular cows that they milked. These cows were especially gentle and never kicked or stepped around.

The woman is pouring her milk into a five-gallon can. On our farm, Father would haul the can up to the house where he kept the cream separator. I remember waking up most mornings to the muffled whir of that separator down in the basement. Some of the milk was consumed by our family. Most of the cream was sold to a creamery, where it was tested for butterfat and priced accordingly. We fed the leftover skim milk to small pigs and chickens, growing in pens or roaming freely about the farm.

Most barn cats were fearless beggars. They would walk freely under the cows or between their feet. Most cows didn't care. During the milking, a mewing cat would sit on its haunches nearby, waiting for you to squirt milk directly from the cow's udder right into its open mouth.

# Early Risers

Every morning, the pride of each old hen was displayed as she clucked and scolded, carefully leading her clutch of baby chicks out into the sunlight. Yellow bundles of fluff ran from one end of the yard to the other, chasing bugs and each other. The chickens scratched and dug for an early-morning handout. The rest of the day they would roam freely, living off the land, picking up grain dropped by livestock that shared the same yard. Free-ranging, they drank from a nearby creek or stock tank and perhaps roosted in a barnyard shed.

During the Great Depression, our chicken eggs helped buy groceries and pay bills. My mother spent hours and hours in her brooder house. We ordered our chicks from the hatchery to come in late March or early April. Most every farm in the neighborhood had a brooder house, equipped with an oil- or coal-burning stove. Thermometers hung on all four walls, and heavy woven wire covered the windows. The building was banked with straw and dirt to seal any cracks. For infant chicks, it was imperative to keep an even temperature in the high 90s for the first week or two, without any drafts.

At first, my father relied on an incubator, kept in the basement, and we hatched hundreds of chicks each year from our own eggs. About twenty-five percent of the eggs didn't hatch, although sometimes it was a little better. I remember well the couple of times I was assigned the unpleasant job of disposing of the unhatched eggs. They smelled terrible. I had to take them out to the cornfield and bury them, deep.

With our own incubator, we ended up with about an even mix of roosters and female pullets. Later Dad switched to ordering chicks so he could get mostly pullets, to lay eggs. Roosters were easy to come by, and hard to get rid of.

The early-morning crowing of roosters served as a good alarm clock for the farmer. My aunt and uncle from the city weren't quite as used to this racket. At least once each summer during the late 1920s they would visit us. After a day or two, Uncle Ed always begged to know where Dad kept his shotgun so when the rooster woke him up the next morning he could go out and shoot it.

During my growing-up days on the farm, when summer was in full swing, I remember it was common to have several hens that would "steal their nests." In some secret place, a hen would hatch a clutch, and then strut around the yard showing off her brood. Predators would usually step in and kill the little chicks before we could supply them with water and feed. One old mother hen hatched out and raised ten at one time. She was still clucking and trying to lead them in late fall. They were all fat and robust, while she was thin and weak, yet she still tried to protect them from all comers.

◆◆◆

Generally by mid-October the new chicks were old enough to begin laying eggs themselves. The chicken buyer stopped by about this time to pick up all the old hens. It was time to bring the new flock indoors to the chicken house. All summer they had been ranging free, roosting at night in trees, on rafters in different sheds, even on barbed-wire fences. Now, we rounded them up and dropped them carefully in their nice, clean, disinfected chicken house, complete with roosts, deep bedding, and lots of feed and water.

❖❖❖

The green wagon in the lean-to shed next to the barn is known as a triple-box wagon. It was a fancy vehicle in its day. In the summertime, it was used to haul grain and livestock. At harvest time, it held oats or shelled corn — exactly 72 bushels for a 36-inch wagon-box height, or two bushels per inch. The wagon-box — double or triple — was a standard of measurement used to calculate payment when small grain was threshed or corn was shelled. For shelled corn, most farmers only filled the first two boxes because the corn was so heavy.

At corn-picking time, the big triple-box wagon held 36 bushels of ear-corn. When corn was picked by hand, each inch depth of ear-corn equalled one bushel picked. The picker was paid on that basis.

The wagon boxes had long, threaded steel rods that held the ends of each box tight. Each time the wagon was unloaded, these rods were unscrewed and the nuts and washers meticulously saved. Several times in each farmer's lifetime, I'm sure, these small items were lost and wire used instead to keep the box rigid until a new set was purchased.

❖❖❖

The triple-box wagon was also used to carry hogs to market, instead of driving them along the road as we did cattle. A wagon like this would hold eight 200-pound hogs comfortably. When the hogs were ready and the farmer decided to ship, his neighbors were alerted and several wagons were rounded up. Usually, they put an extra twelve-inch board around the sides because pigs would sometimes jump or crawl over the side and get injured in the fall. Even if a pig didn't get hurt, it was next to impossible to get him back into the wagon and on to market.

One time, for some reason, Dad didn't think the extra board was necessary. Several neighbors came over to help my dad haul his hogs away. Sure enough, several jumped out, and one got hurt in the fall and had to be butchered. I guess Dad figured the pigs, being his pets, would all ride quietly and not cause any trouble. But when they heard their mates squealing in the other wagons nearby, over the side they went and suddenly there were Chester Whites all over the countryside.

They were all rounded up except the one that got hurt. The Great Escape of Dad's market pigs was the main topic at our table for a long time.

The next time hogs were taken to market, we added an extra board on top, all the way around. My big brother was assigned the job of hanging on the back and poking any pig passengers in the nose so they wouldn't jump out.

❖❖❖

In the lower left-hand corner of the picture is an old-fashioned dump rake. Pulled by two horses or mules, the rake's teeth slid along the ground, rolling mowed hay into a bunch. Periodically, the operator pulled up the handle, dropping the collected hay in a bunch.

As he crossed a field, back and forth, he left the hay bunches in lines to create long windrows. Then, we would follow each windrow with a team and hayrack, loading the hay with forks. The hay was hauled to the barn, or sometimes to a corner of the hayfield to be stacked and retrieved later, maybe not until the winter.

Riding the dump rake, you needed a mighty strong arm to pull that handle to drop the hay bundles in windrows. We also sometimes used the dump rake when we threshed. After a soaking rain, the butts

of small-grain shocks had to be turned up to expose them to the wind and sun to dry. This machine was an excellent tool for that purpose. We could also turn a windrow of hay over if it got wet, letting it dry before it was collected. Some farmers mounted heavy springs on the axle to make it easier to lift the teeth from the ground.

On later versions of the dump rake, the axle was keyed to the wheels, driving a gear box that raised and lowered the teeth, relieving the operator of lifting the teeth by armpower.

The dump rake was also very wide. When approaching a farm gate, you had to be very careful to guide your team to enter squarely, and then proceed through cautiously without hooking either wheel on a post, which would cause the axle to be sprung.

Because of its drawbacks, the dump rake soon gave way to the side-delivery rake. This improved device had teeth and cylinders that swept the hay to the side, leaving one long windrow. However, Dad never got one of those. We just used the old dump rake, and got strong arm muscles pulling that lever. In later years, he hired a fellow with a baler to drop bales of hay in the field. Then we went and picked them up with a wagon and brought them in.

◆ ◆ ◆

One time, a neighbor helped my brother-in-law rake hay with a dump rake that he had hitched to a team of mules. Mules in general were good, hard-working animals. The neighbor had raked the hay and started for home, down a long lane with several trees shading its dusty tracks. Unfortunately, coming into the lane he hooked a tree that stood close to the track.

The mules sensed they were on their way home and didn't regard the tree as much of a factor. They took off at a fast pace. Dust rose from those big round wheels as the mules gained speed and confidence. Home meant good-tasting water and a feedbox of oats. For the farmer, standing on the small space provided on a dump rake left little leverage to slow them even a little. Men that handle mules will testify they are harder to hold than horses if frightened, and these were no exception.

They hooked several more fenceposts and trees going down the lane and then bounced over an old cement bridge. They proceeded out onto a black dirt road, sometimes traveling in the ditch and sometimes on the road.

The farmer finally got them turned into a plum thicket where they stopped. The rake was a total loss but neither mule or man was hurt.

# The Ice Wagon

It was exciting when the iceman stopped his wagon at a farm. In this picture, the little girl is chewing a chunk of ice, while the young boy reaches for a choice piece. A handsome black dog waits patiently, hoping for a tidbit of the delightfully cool ice. His brown-and-white counterpart lies puffing in the shade of the wagon.

A sign was placed in the window to let the iceman know to stop his wagon and deliver ice. The iceman would take his tongs, set them firmly into a block of ice, and lift the block onto a spring-scale hanging at the back of the wagon. Then, he swung the block to a pad on his shoulder and carried it into the farm kitchen.

The iceman knew right where each family's icebox was. He would open it up and place the new chunk in the empty compartment. The family could leave the farm for a few hours with the ice sign up, knowing the iceman would take care of refilling the icebox on his own before they got back. They would just pay for the ice the following week.

When fully loaded for a trip through the countryside, the iceman's wagon was very heavy. Most ice wagons had brakes as shown in the painting. The brake is a block or shoe that is pressed against the back wheel when the driver pulls a lever, stopping the wheel. Otherwise, horses would have trouble holding a heavy load on an uneven farmyard or a hilly country road.

This wagon has a cushioned seat for the driver because of the long day's ride. It was one of few luxuries afforded an iceman in those days. Stopping and starting, carrying those large chunks of ice up to many houses on his route, he appreciated the pleasant rest a cushioned seat provided. On the road, he was sheltered from the hot sun in his driver's seat, and probably felt some of the chill of hundreds of pounds of ice in the back of the wagon, even though it was covered with damp sawdust to seal in the cold.

A highback rocking chair sits on the front porch bordered by a freshly-painted balustrade. With clean, glossy pillars and rounded struts, this is a fine farmhouse porch.

The ice was used not only to preserve eggs, milk products, and meats, but also to cool the delicate sweet-tasting lemonade the housewife served out in the field at harvest. A small snow-white tablecloth, draped over the back of a wagon or buggy, was used to serve a late-afternoon lunch.

Sandwiches with strips of cold meat were served with tasty sweet pickles and pickled crab apples. Assorted cake and cookies — even a leftover piece of pie — might be sent out to the field as an extra treat. Several chunks of ice were dropped in an open porcelain kettle with lemon juice, sugar, and water. The tangy, icy-cold mixture helped relieve even a harvester's thirst.

The white horse appears to have a sore foot, lifted above the ground as though it were tender. Horses working on the road were subject to getting sore feet because of the hard-packed surfaces. Long distances traveled each day added to the discomfort. The iceman might need to soak the tender feet of a team and give them several days off. To keep his delivery route on schedule, he might have several teams, alternating them to keep the horses fresh and in good health.

# Haying Time

This scene brings back memories of summer heat and an Iowa farm boy helping his dad put up hay. In late June and early July, hundreds of acres of wild hay across Northeast Iowa were mowed and raked into piles, waiting to be hauled to barns and put in haymows for storage. Making hay was usually a family job. It's hot, with very little breeze, and it seems like Mom is late with the afternoon lemonade.

Wild hay was long stemmed, brightly colored, and easy to cure. It grew on land that had not been tiled and was too wet to farm. The hay came up voluntarily every year. Usually, a farmer got only one crop, or cutting, although occasionally you could go back and cut a second crop.

Wild hay was very hard to handle. It slid easily, consequently it was very hard to get a fork-full. It took a long time to get a load ready to haul to the barn.

On the load of hay in the picture I don't see any ropes tied to the front and back of the rack. We called them slings. A sling consisted of three ropes, laid out straight and parallel, then tacked onto several long boards to keep the ropes spaced apart.

The farmer would lay the first sling on the empty bed of the rack, then fill the rack about half-full of hay. Then he laid out another sling and finished the load. To unload at the barn, he used another rope to hoist each sling, nearly half a load of hay at a time, to an open haymow door just under the peak of the barn. It took two horses to pull a sling of hay up into a mow, since they were lifting a tremendous load.

From the haymow door, a carriage ran inside the barn, from the front of the mow to the back. This pulley track allowed the hay to slide to any place in the mow. In the middle of the sling was a spring-loaded trip bolt. When the farmer jerked on a release rope, the sling came apart and the hay dropped in the right place in the mow. As it fell the hay spread out, giving more ventilation and making it easier to pitch it down later.

Some farmers used a hay-fork to get the hay into the mow. The hay-fork was a heavy, hinged frame, about two feet by four feet, that grabbed the hay in smaller bunches and pulled it up to the carriage track. Only one horse was needed for this lifting operation.

It looks like this farmer will unload his load with a pitchfork. There are no slings on his hayrack and no ropes coming from the hay door on his barn. At the barn, he will stand on the load of hay and pitch it up into a lower door on the haymow, where one of his sons will spread it around. This was hard work, but countless tons of hay were put away with that method.

The farmer didn't dare cut more hay than he and his sons could put up in a day. It was important the hay was cured and dry before storing. Damp, loose hay would heat or mold when put in a haymow, spoiling it. It could even explode from spontaneous combustion. Throughout the region, these tragedies always made the news.

Trees and bushes line the lane to the farm buildings. A wide, wooden bridge connects the hayfield with the house and barn. The bridge looks sturdy enough that run-off from a heavy rain won't wash it out. In the background, two huge mounds look down on a small stream or pond. It looks like this farm is well endowed with plenty of pasture and hay ground.

# A Rainy Day

The haymow on a rainy afternoon was a favorite place for young neighbors to talk and make decisions. The rain rattled on the roof as lightning flashed and thunder growled. The afternoon's sudden shower cascaded through the yard and created dams — piling up debris against fences — forming small lakes that soaked away by chore time. The warmth of the summer afternoon still hung around the new hay in which the two boys reclined, while cool zephyrs of damp air touched their faces.

It was a chance to discuss their lives on the farm. A sturdily-built straw hat, with a fresh look that hints it was bought just for this harvest season, rests leisurely on the stored hay. The boys are barefoot, alone and independent for the afternoon — as long as it keeps raining.

Before the rain, the boys' duties might have been making hay. Loading and pitching the hay off was a hot and tiring job. Or perhaps they were helping thresh oats by carrying cool drinking water to the men or helping haul grain from the threshing machine, a particularly hot and dusty site.

Now, the wet, cool rain has revived their spirits. Being alone, they talked their own language. No more fieldwork for this day. A heavy rain would soak everything so it was too wet to make hay, or thresh, possibly for several days.

The wet, shaggy dog looks contented as well, lying with its head on one boy's leg, enjoying the scratching. Green, lush hay piled by the open door made the perfect cushion from which to watch the rain and discuss topics of boyhood importance.

The solid lumber of the haymow hints it was built when they still measured lumber in full inches. Heavy, rough planks lie clean at the open door where the boys look out. The swinging haymow door might squeak in the breeze. Outside, ducks cavort and dance in the rain as the boys visit and enjoy their break from farm work. Beyond the mow door, a triple-box wagon stands quiet and empty, the spring seat ready to ease a rough ride on the next trip to town.

Now, the lightning flashes are further apart. The hog house and solitary box-elder tree shrug as the clatter of the raindrops softens. A ray of sun touches the top of the tree and sparkles brightly like a new day. Suddenly, a flood of sunshine touches the eastern sky. Orange, rose, and violet arch across the sky and are lost in a mass of clouds. Soft hues turn deep, and then fade as the sun splashes bright light against the hog house and the last drops hit the roof.

A Northwest Iowa rainbow fades. Chore time isn't far off. There's just enough time to get some cookies and lemonade to satisfy these young farmers' hunger until supper.

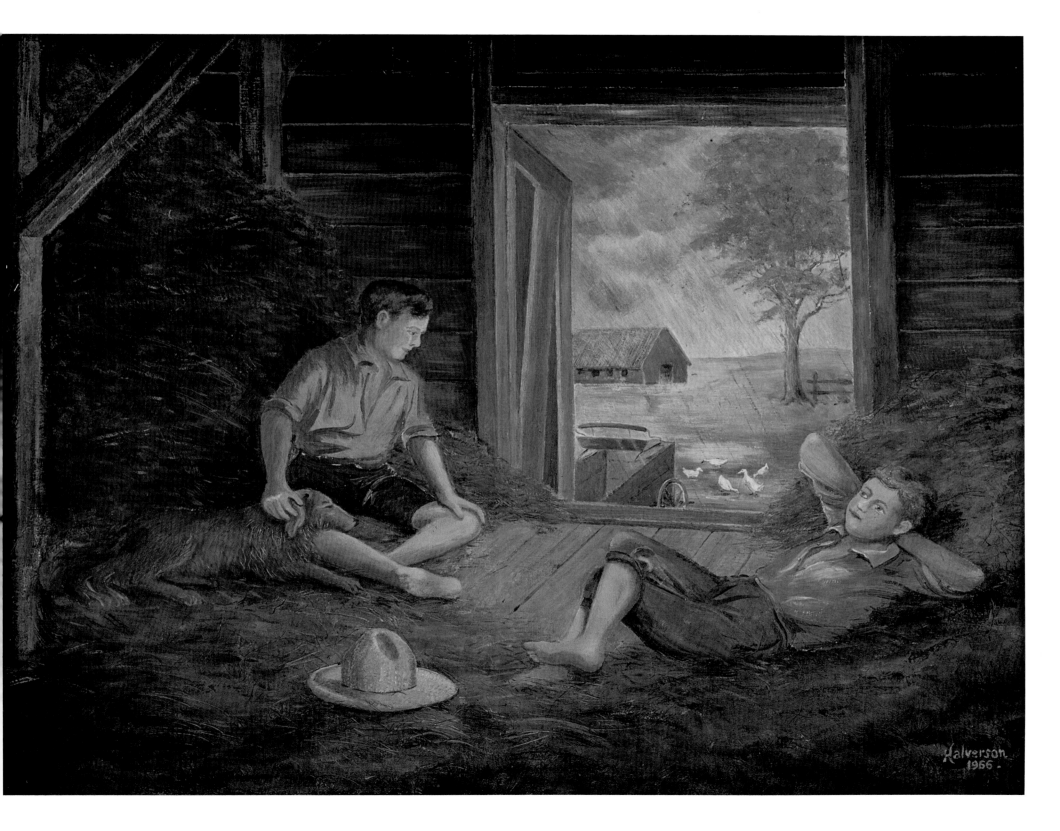

# Neighbors & Townfolk

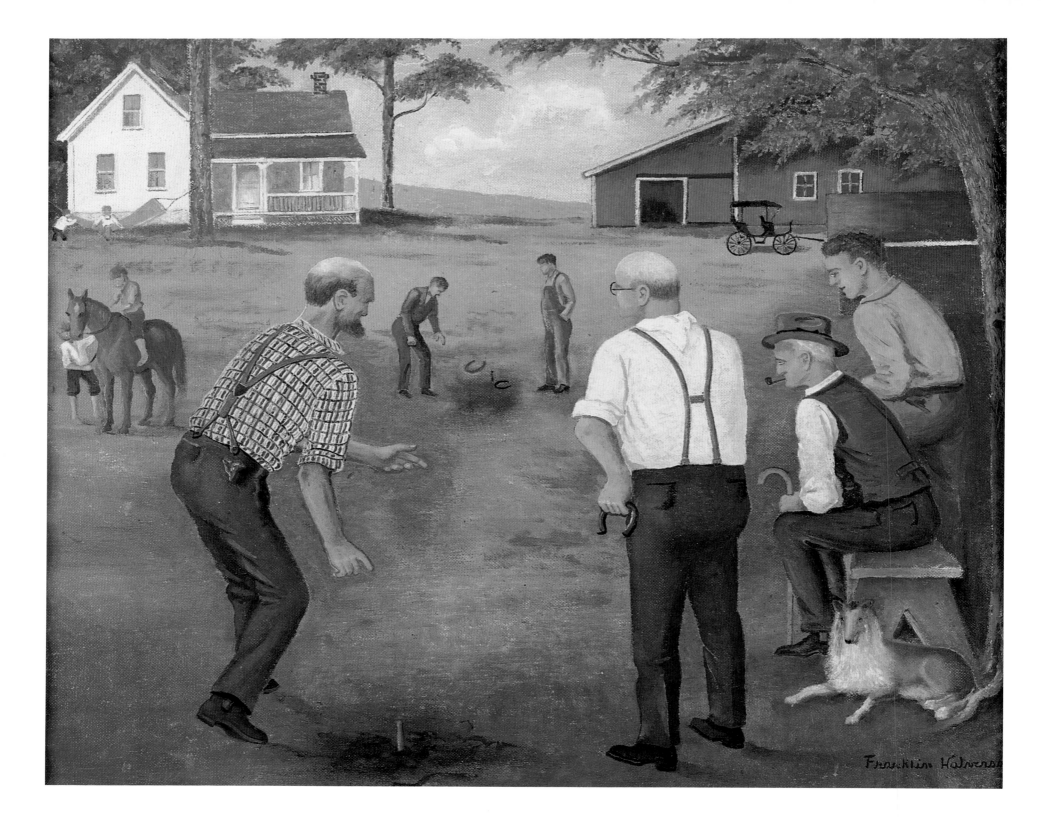

Franklin Halverson

# Sunday Afternoon Horseshoes

Four men pitch horseshoes while two more watch on a Sunday afternoon. The skies are blue with fleecy, white clouds riding the wind. The carpet of green grass reaches all the buildings, but is worn thin where the game is played.

Horseshoes can be played by two, three, or four persons. If three play, each player counts his own score. People of any age can play, as long as they have the armpower to swing and toss a horseshoe the distance between the two stakes. The game requires a yard reasonably level with enough room to place two stakes forty feet apart. Avid players will build a "pitching box" around the stake, with a soft mixture of sand and clay soil for the shoes to land in solidly without bouncing.

Points are scored by getting your horseshoe around the stake, or at least close to it. Three points are scored for a "ringer," when the shoe encircles the central stake. A key test is that an imaginary straight-line connecting the tips of the shoe must clear the pin without touching it. A "leaner" counts one point. If no ringer or leaner is scored, the shoe that lands closest in each set of throws can gain a point.

One method of scoring counts all points. Another method cancels out matching throws, and scores points only if a throw is better, such as if only one player or team makes a ringer.

Each player has a personal throwing technique. Some release the shoe with a flip of the wrist so that the shoe will turn over a few times before coming in for a landing, hopefully right around the pin. The resounding clank of a ringer is beautiful music to the ears of a horseshoe pitcher.

Horseshoe pitching has been popular for ages. Supposedly, the Romans originated the game and introduced it to Britain when they ruled that province. Later, the game came to the American colonies with the English settlers.

Official rules were established in 1920 when the National Horseshoe Pitchers Association was formed. Pitching-box measurements and the distance between the stakes were made uniform. This painting could be of a game before the regulations were set. There is not a pitching box for the shoes to land in. A patch of black soil serves the purpose. I would doubt they had regulation-weight horseshoes, either. House rules would be spelled out before the game began, and the challenge was on.

The game is still popular today. City festivals, county fairs, and state fairs have horseshoe-pitching contests every year where local teams and regional clubs meet to renew friendly rivalries.

A spirited contest is in progress here. The two gentlemen in the foreground skirmish for a crucial point. One of them has thrown both his shoes, with one shoe looking like a point while the other is too far away from the pin. The deciding throw may be at hand. The two fellows on the bench are keeping abreast of the action, while discussing the ins and outs of farming on the side.

Horseback riding was another favorite Sunday pastime, especially for the younger folk. The horse is gentle and willing, giving the boys the confidence they need. A four-wheeled buggy sits empty in the yard.

If the men walked closer to the house they could hear the clatter of Sunday dinner dishes and the laughter of the women as they finished cleaning up the kitchen. The aroma of sweet black coffee filtered through the house, to finish a lovely Sunday's gathering of friends.

# Main Street

Main Street in Sioux Rapids was typical of any thriving town on the early frontier. On the right, scanty pillars support the outside mezzanine of a downtown hotel known as the Central House. The man sitting on the bench in front might be waiting for the stagecoach to Spencer or Sioux City. His steamer trunk and leather satchel are close at hand.

The Central House, built in 1870, was indeed central to the town's development. It provided lodging for travelers seeking land or business opportunity. The elderly gentleman with the cane, standing in front of the hotel, visits with a man on horseback, perhaps giving directions.

Across the wide street, the livery man is leading a fancy bald-faced sorrel out of the livery barn and feed store. He will hitch the horse to the buggy parked nearby. The top is laid back, showing a silky interior. As the buggy moves down the street, the top can be pulled ahead to shield passengers from the weather.

Down the middle of the street, a farmer urges his team pulling a green double-box wagon. They are on their way to the mill to pick up his sacked, ground wheat before heading home.

Looking farther down the street on the left, the tall facade of the Opera House awaits its next event. Built in 1894 by investors of the Sioux Rapids Bank, the facility could seat nearly 400 people. Tonight, traveling thespians might perform a melodrama. Gifted speakers might deliver thunderous orations, or arias might echo through the street. Fancy buggies would be parked shoulder to shoulder up and down the thoroughfare.

As the last clear strains of the evening's performance faded, people would line the street and head to the nearby Parker House for refreshments. Reservations for dinner and spirits were made early, as it was considered one of the most desirable places in the community to eat.

Local general stores like I.B. Christenson's carried full stocks of every kind of dress goods, notions, boots and shoes, hats, groceries, crockery, and glassware. Hardware stores sold items large and small, from ten-penny nails to windmills, plows, and planters. Butchers sold meats and grocers sold vegetables, produced locally or shipped in by railroad on iced freight cars.

Furniture-makers sold dining sets, pianos, and coffins, and doubled as undertakers. Restaurants sold cigars and oyster dinners. The manager of the feed store was a justice of the peace. Jewelers and milliners, dentists and barbers, harness-makers and bakers, wheelwrights and grain dealers, all had their clientele and offered services to the bustling frontier community.

The mark of good service was that you were treated with respect, whether you spent a nickel or ten dollars. Many businesses extended credit, and the trustworthiness of a person's word was a valuable asset.

It is interesting to realize that in Sioux Rapids in the late 1800s, there were three lawyers, three doctors... and three blacksmith shops. Times have changed.

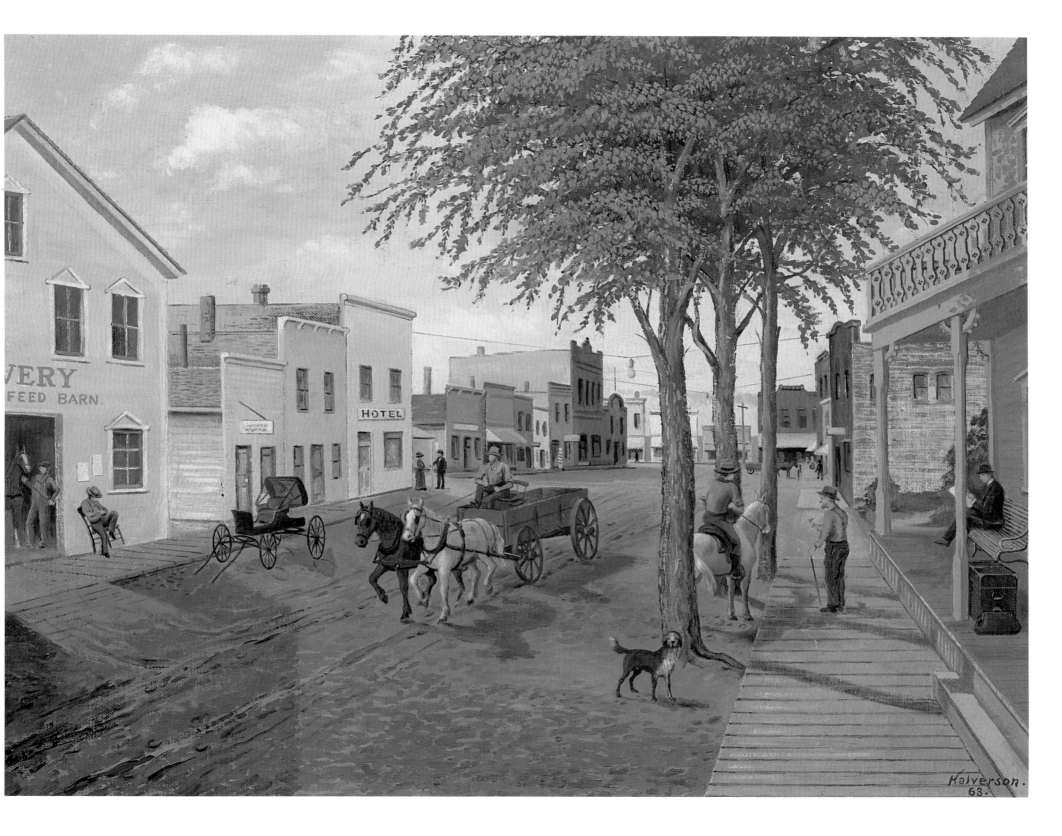

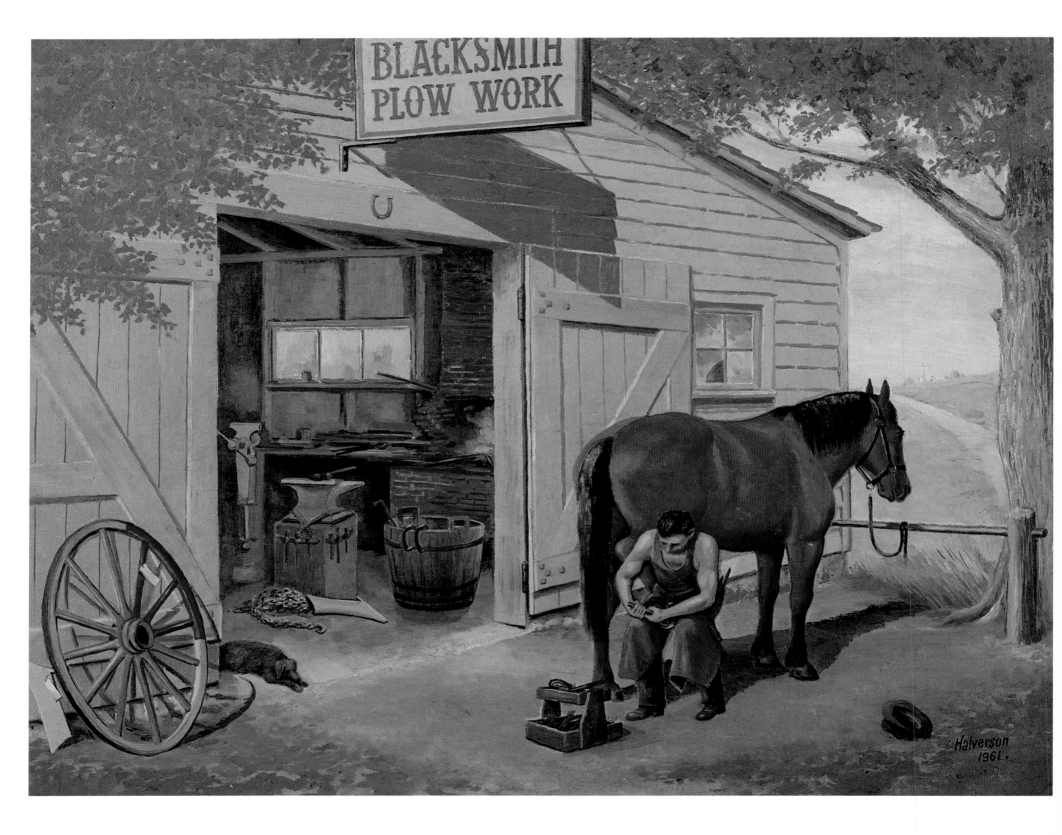

# Village Blacksmith

Red coals in the forge are glowing, ready to soften another horse-shoe so the blacksmith could fit it to the horse. The smith would pump the bellows lever, sticking out from the base of the chimney, to intensify the heat while he held the shoe in the forge with a sturdy pair of tongs.

Close to the fire is the anvil, ready to help shape and bend the heated metal when it is drawn from the forge. Then, the smith would dunk the hot shoe in the small water tank, to cool it before nailing it to the horse's hoof.

The only advertisement for this shop was its sign, hanging solidly over the shop door. Besides shoeing horses, the smith also made and fixed all sorts of metal items found on the farm: hinges, latches, farm and household tools. All blacksmiths were good mechanics with equipment. They also had good rapport with animals, especially horses.

A plowshare lies at the base of the anvil stand. The share-blade was attached to the lower part of the plow's moldboards. The share's point became dull with use, especially on a rocky field. Periodically, every farmer's plow was brought in to be sharpened. The smith would heat the share and weld more metal on the point. Then the red-hot metal was shaped and sharpened along the blade's leading edge where it did the work of cutting and breaking the heavy soil. Blacksmiths repaired hundreds of plowshares in fall and spring.

The smith was also a wheelwright. A partly-painted wagon wheel leans against the open shop door, and a log chain lies loosely at the base of the anvil stand. When the farmer comes to get his wheel, he and the blacksmith will hoist the wagon up with the chain, and slip the repaired wheel onto the axle. The wheel has a tag on one of the spokes, probably a note with the owner's name and charges on it.

Today, the smith has chosen to enjoy the warm day by working outside. The smith's toolbox sits close at hand as he shoes the beautiful sorrel with front black stockings, black mane and tail. In the tool kit or hanging nearby on the anvil stand are tongs, a rasp, nippers, clinchers, and a shoe hammer.

Hoof knives, picks, and nail-hole punches would be put away safely in a drawer in a cabinet or in a slot above his workbench. Smiths were busy and worked quickly, and had to know right where each tool was. Some tools were used so often they were seldom put away.

He appears to be using the nippers to trim the hoof or the clinchers to clip the nails around the hoof. His heavy apron hangs loosely, protecting his knees and thighs. His hat is on the ground. The horse's tail probably tipped it in the dust aiming for a hungry fly on its leg.

A chunk of glass is out of the small window above the horse. Business must be good as the smith hasn't had time to replace it. The traditional lucky horseshoe is centered over the shop door below the sign. Tree branches reach toward the peak of the building, giving good shade to the smithy.

A black dog rests in the doorway, half-asleep yet not missing anything. Most blacksmith shops had a dog that roamed the premises. If you were a stranger, the owner didn't want you to handle anything unless he gave it to you. He taught the dog to be watchful and to snap and growl if a customer touched anything. It was one way the owner protected his valuable tools.

# The General Store

When I was a youngster, a trip to town with my dad meant a stop at the blacksmith shop, the general store, the lumberyard, and the feed store before we headed home to the farm.

The general stores were willing to trade food and cash for fresh produce straight from the farm. We would bring in cream, eggs, and chickens. Most stores had cream-testing equipment, with a centrifuge to spin the cream sample. The proprietor "candled" eggs before he bought them, holding them up against a bright light to make sure they were clear of an embryo or other signs of spoilage.

People would line the counter waiting to give their order. Most foodstuffs were behind the counter. Each purchase was written down and the item handed to the customer. The total was added up, and then the store owner subtracted the value of the eggs or cream you brought in. He sometimes gave you a check for the full amount of your produce and then cashed your check. Many folks charged their bills until the end of the month.

Some stores had a tradition of being open two nights a week, Wednesdays and Saturdays, especially for the farmers. Shelves were well stocked for the occasion with canned and dry goods. A new shipment of bib overalls or several bolts of cloth enriched the counters, and new aprons were draped over a table to catch the eye. A new shipment of coffee was especially tantalizing, as the whole store reeked with a sweet, inviting coffee aroma.

When I was young, candy bars sold for five cents apiece, but on Wednesday and Saturday nights it was three for a dime. We would pool our money and have extra candy bars to divide.

I recall one occasion when three young fellows, aged ten or eleven, pooled their money and got three candy bars. On their way out they noticed Hinnshaw, the cat, sleeping on an empty shelf. Many stores had a cat that roamed the premises with impunity, stalking the mice and rats that otherwise could undermine a store's profits.

Hinnshaw looked up from his post and yawned as the youngsters slipped out the door. They unwrapped their candy and chewed on the sweet, succulent morsels. After they had devoured the candy they decided it was too early to go to bed. They giggled as one of them speculated what Hinnshaw would do if a couple of sparrows got loose in the store, just at closing. In an old shed close by, they took advantage of the darkness and each caught a sparrow.

The last customer shouldered his big box of groceries and headed for his buggy in the dimly-lighted street. The boys slipped in and let the birds loose. The flutter of wings aroused Hinnshaw to a frenzy. He dived through merchandise, careened around the aisles, and sprang up the ladder used to reach high shelves.

Finally the birds settled down on an electric wire. Hinnshaw struggled desperately as the grocer threw him out the door. Not surprisingly, it was a long time before that trio of boys ventured close to the inside of the store, regardless of special prices on candy bars.

The butter churn, lantern, horse collar, and other merchandise on display suggest some of what was needed to operate a farm. The china cupboard on the far side of the store depicts dishes and assorted lamps of the era. A potbellied stove heats the room. One man is warming his backside and watching a checker game played by two older gentlemen sitting in shirtsleeves. While the player on the left stacks his opponent's pieces, the fellow on the right has very few moves left.

A gray-and-white cat sleeps under the chair, perhaps dreaming of sparrows.

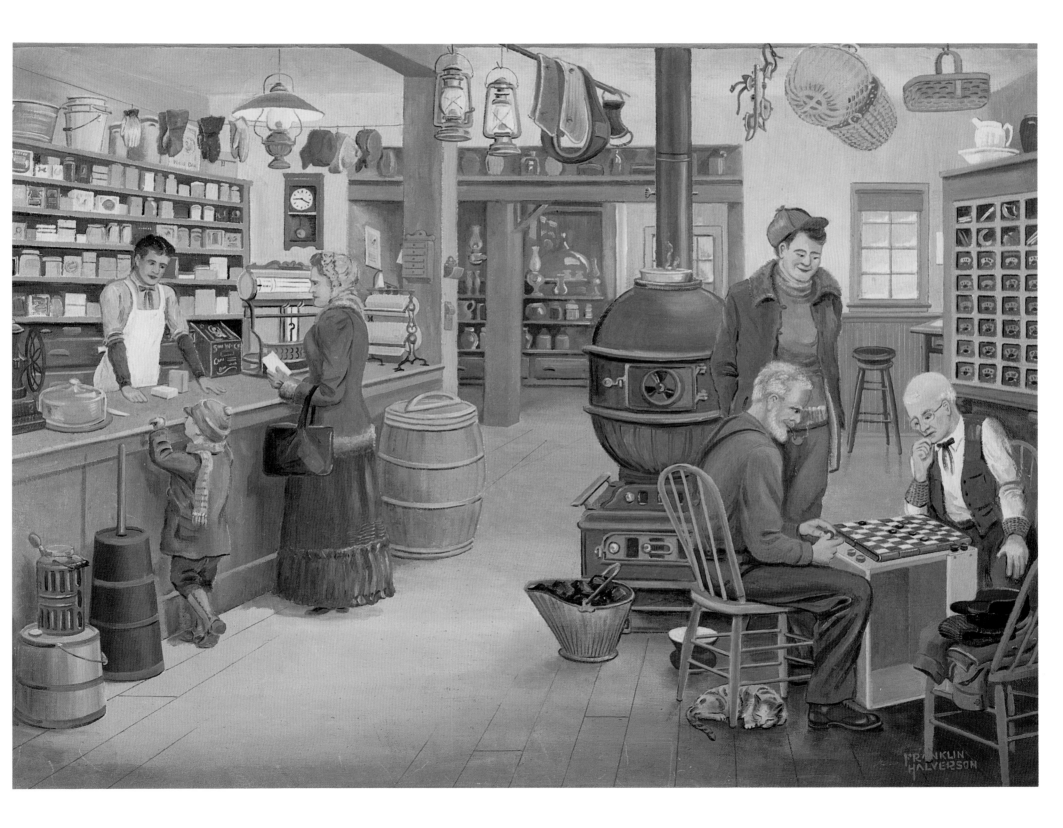

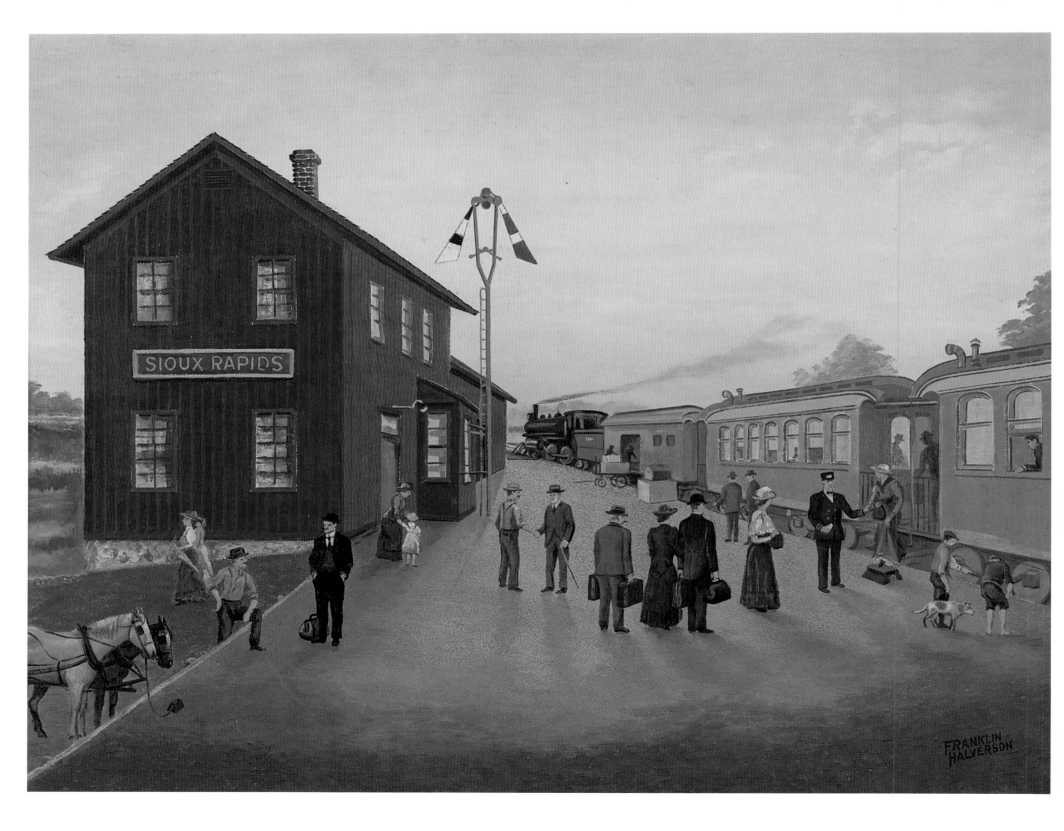

# Depot at Sioux Rapids

The depot was often a busy, bustling place. Over the years, thousands of travelers disembarked onto this platform, eagerly reading the sign for Sioux Rapids that introduced them to the town they had been looking for during their long trip across the prairie.

The platform felt the footsteps of passengers coming and going. It reverberated to shouts of joy as friends and relatives arrived, and echoed sobs of grief when people left. It felt the springing pace of a growing community, people with brisk steps anxious to buy land or engage in other business opportunities.

This depot was established in 1881 after the Chicago and Northwestern Railroad started a run from Eagle Grove through Sioux Rapids, and south to Denison. The station was located at the base of Broad Street until, about 1910, it was moved to Front and Second Street.

The depot agents received lots of respect. Anyone who could listen to the clickity-click of a telegraph instrument and make sense of it was considered an ingenious man. Sending and receiving messages in Morse code was a skill that awed most folk. The agent's knowledge helped mold the town's progress, as train and telegraph connected Sioux Rapids to the outside world.

A special cap was always worn by the depot agent so that passengers would know who could answer their questions. The arrival of the morning passenger train was the start of many things. The whole town could be influenced by who and what arrived in the way of passengers and packages. Large packages were especially intriguing, with return addresses of far-away places and the names of lucky persons for delivery.

From the telegraph, the agent knew if trains were late. He was the first to hear news of weather and epidemics up and down the line. The stations within a given network all received each others' messages, but only responded when they heard their own call letters.

Many people have seen in a small depot a red tobacco-can slipped over the Morse-code instrument. This was used to amplify the sound of the clicking dots and dashes, so they sounded like they came out of a large washpan. Then the station master could work around the depot and still hear his call letters. The agent could be in the middle of a conversation with a customer, hear his call letters, and excuse himself to answer the call.

The clock that sat in the station was checked every working day at a certain hour. All messages ceased for three minutes. Time was spelled out on the mechanism and at the last dash, the time was set in every station up and down the line.

Depots were not air-conditioned and their windows were seldom washed, but they all had potbellied stoves. A late traveler waiting to flag a train, perhaps not until early the next morning, would find a full scuttle of coal left by the stove, ready to keep the place warm until train time.

One of the features of departing from a small-town station after regular hours was the art of flagging a train to stop. A green lantern was kept handy, full of oil and well-polished. The traveler would light the wick when he saw the train chugging toward the station, then stood in the track waving it back and forth to alert the engineer to stop.

# The Flour Mill

Before the settlers arrived, this region was a land of waving grass, placid lakes, and tree-shrouded rivers that wound through the prairie. Herds of buffalo and elk ranged freely, and Sioux Indians traveled through the area on their traditional routes.

The earliest white settlers first lived off the land, hunting wild game to survive. Shoulder-high grasses covered the prairie like an endless sea. There were no fields of corn, oats, or wheat. Gradually, the determined pioneers plowed under the grasslands and planted grain crops. In small towns, grist mills sprang up to grind flour for settlers' bread. Other water-powered mills sawed walnut, oak, and hickory logs from the river bottomlands into boards for building homes and barns.

The Sioux Rapids Flour Mill drew people from all over Northwest Iowa. Built in 1867, it saved local farmers the long arduous trip to the closest mill at Fort Dodge, over fifty miles away, a trip of several days. Weather was unpredictable and there were few settlements to provide housing along the trail.

Even getting to a nearby mill often meant an all-day round trip. In springtime, trails could be soft and muddy. Early sunrise would find farmers plodding along roads toward the mill, wagons heaped high with sacks of grain. The horses pulled their loads valiantly, struggling through mud or dust depending on the weather. In the wagon with sacks of grain would be several dozen eggs, padded against the jostling bumps, with some chickens and perhaps a shoat, securely tied, to barter for needed supplies. In rainy weather, trails got longer if a farmer had to detour to a better ford when his regular crossing place became impassable.

The farmer would typically leave his wheat to be ground while he went to do some shopping at the general store. When he got back to the mill, his flour was sacked and ready for loading. The team would be rested and ready for the long trek home.

A dam held back the water of the mill-pond. One cascading channel was diverted past the base of the mill to create the power to turn the mill's big wheel. The huge wheel was sheltered behind the rocks that provided support for the main structure.

The mill dominated this stretch of the river. Its squeaking machinery woke birds and animals that lived in the green jungle of trees lining the banks of the Little Sioux. The mill's broadside echoed the crunch of gravel under wagon-wheels arriving heavy with loaded grain. The mill converted the energy of the flowing river into a stream of flour. Farmers waited, happy to load their heavy sacks of the precious staple.

In 1881, after the Chicago and Northwestern Railroad came to Sioux Rapids, the growing town became a hub for a larger district of farmers. Grain could be brought to Sioux Rapids and shipped to far-off markets. The Minneapolis and St. Louis followed suit, putting in a line at the turn of the century. To generate more shipping business, the railroads sold tracts of land at good prices to farmers.

In about 1902 an excursion launch was installed on the mill-pond, offering rides for several miles up the river. Some days it was kept busy popping along on its single cylinder. In this painting, the pleasure boat is tied up at the dock, close to the trees. The dam was a favorite spot for summer fishing, and, in the winter, skaters traveled for miles up the river on clear, thick ice.

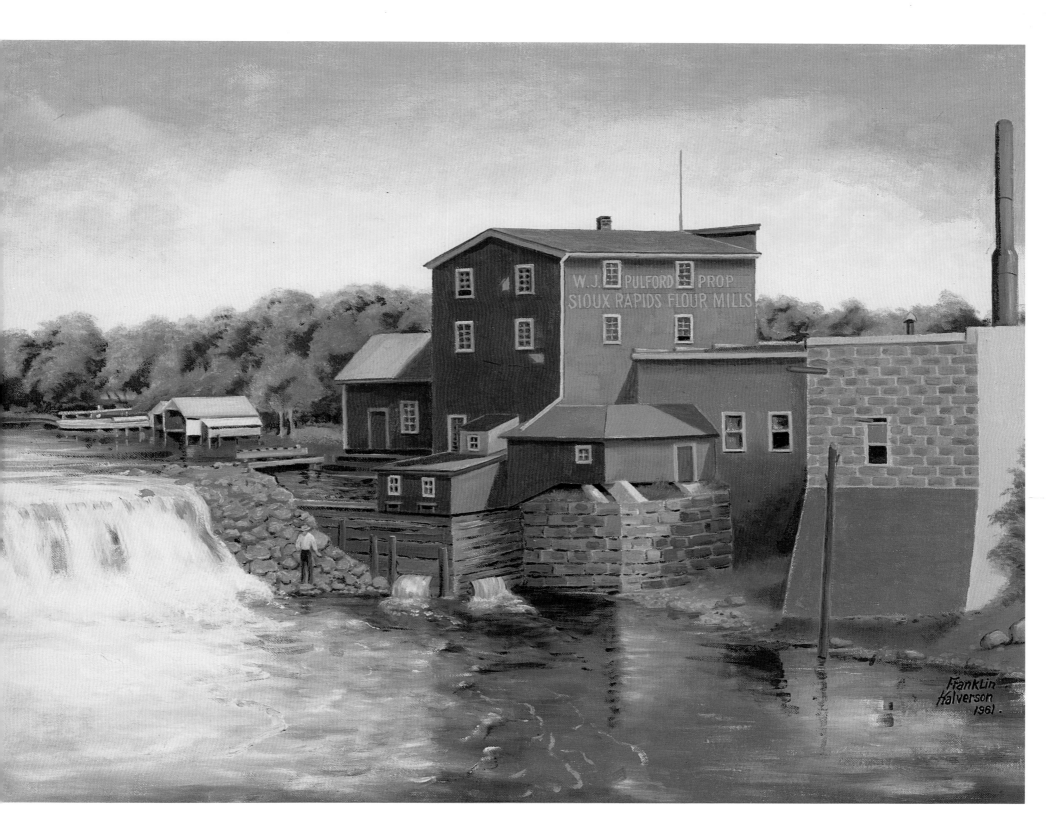

W.J. PULFORD PROP
SIOUX RAPIDS FLOUR MILLS

Franklin
Halverson
1961.

# Country Doctor

In the eyes of many farmers, the country doctor was a miracle man. His services were called for time and again, especially during the epidemics of the late 1800s and early 1900s. Before the days of the telephone, calling for a doctor often meant riding or walking some distance.

Here, the housewife greets the physician from the door, ready to show him to the room of the sick person needing care, whether child, husband, or hired man. The doctor did his best to hurry from place to place, but was often late, it seemed, because other people needed him, too.

The dog is crouching at the gate, perhaps unsure whether to let this dark-clad, unfamiliar person approach the house. The doctor talks to the pet in his most soothing bedside voice, while the house-wife gives the dog a stern warning to let the doctor pass.

Country doctors made their rounds on hot and windy summer days and on bitterly cold winter days. Weather had to be miserably bad to keep him at home. Treating patients in their homes on the frontier was difficult, as homes had small rooms with poor lighting and lacked running water.

The doctor in this picture doesn't seem to be in a particular hurry, so this probably is just a routine visit. He is carrying the familiar black bag all doctors used. It contained a variety of basic drugs that might be needed and instruments for examining patients. The most common were a thermometer to check a patient's temperature and a stethoscope to listen to the thump-thump of the heartbeat.

The doctor also educated other members of the household to be acting nurses, to care for the patient and try to relieve pain or fever in the absence of the doctor. Especially during the influenza outbreak of World War I, all available doctors and nurses worked day and night. They made constant calls to administer to the sick and taught others to help as best they could, in an attempt to handle the tremendous numbers who fell prey to the dangerous illness.

◆ ◆ ◆

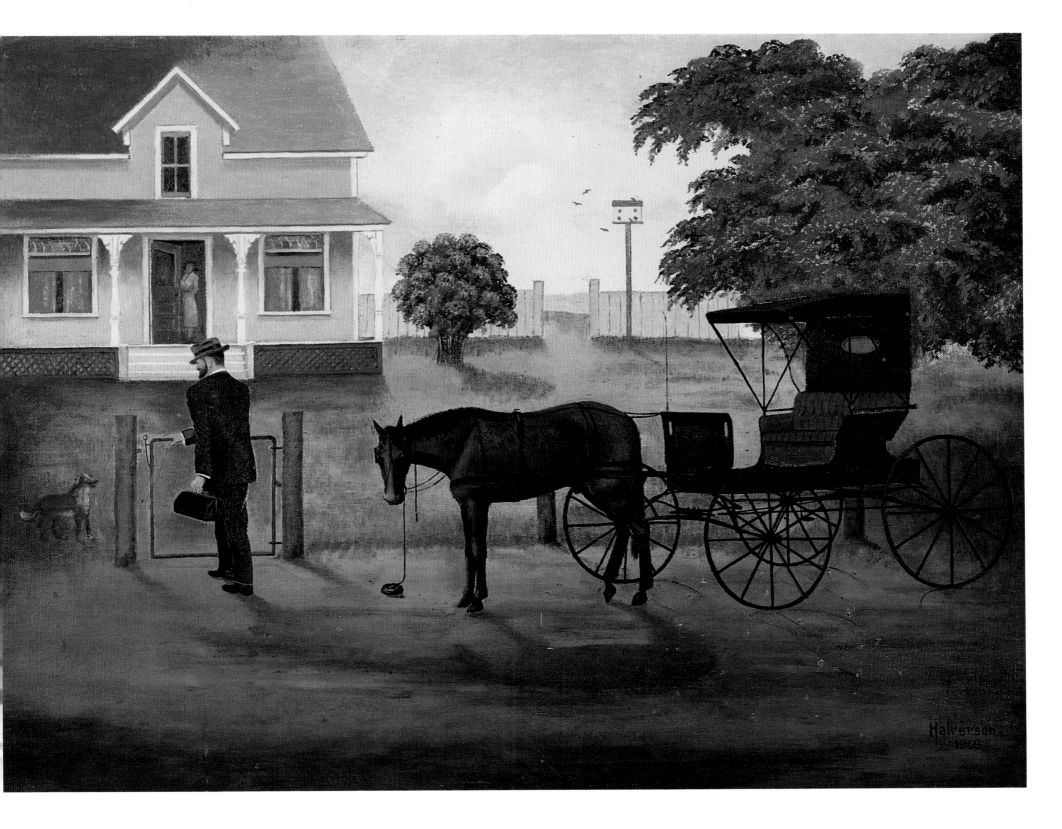

The calm, quiet horse is ground-tied with the "stop drop" often used in those times. The buggy is one of the latest models, with springs to ease the ride over rough terrain. A very busy doctor might have a hired man to drive while the doctor slept in the carriage. As the driver pulled into the yard, the doctor would hit the ground, running to the sick people in the house.

Meanwhile, the driver would unharness the team of horses, take them to the barn, and dry them off, because they would be lathered and wet. He'd rub them down and walk them until they cooled. This was especially important in wintertime because horses would get very sick if not cooled correctly. After the team had been cared for properly, the driver might have time to catch a few winks himself before the doctor was finished and they started out again for the next call.

The painting shows a well-kept yard with lush grass and a blooming lilac bush standing leisurely beside the house. An apple tree covered with blossoms bursts forth with green, luxuriant branches that reach into the sunshine.

◆ ◆ ◆

For minor ailments or injuries suffered in daily work, the farmers often used home remedies. Based on experience and hearsay, they concocted a wide-ranging variety of liniments, salves, and homemade potions.

In the fall when farmers picked corn by hand, they were often bothered with chapped skin from rough corn-shucks constantly rubbing against their skin. I remember one of the fellows who was picking for my father coming in for supper one evening with his wrists swollen way out of shape. They were red, puffy, and terribly sore.

Mother offered him a cup of coffee but he was afraid to try to pick anything up. His wrists had been fine as long as he was picking, but when he came in to unload and unharness his team, the wrists swelled up so bad he could hardly move his fingers. I don't think he was destined to be a corn picker very long.

Discussing it, he told us of someone who had recommended a mixture of turpentine and goose-grease as a salve. After that, we occasionally tried this pungent ointment ourselves. It seemed to help, especially in the wintertime when skin got rough and irritated. Mother wasn't too keen about the smell, however, that penetrated the house. She had a sensitive nose.

◆ ◆ ◆

Colds were always a big problem during school days in the winter. The one-room school house was crowded, poorly ventilated, sometimes very warm, and most times too cold. Some of the kids caught colds easily. A home remedy of the time was to take a teaspoon of white sugar with three drops of kerosene. You dissolved it in your mouth and swallowed.

I can't recommend this to anyone. It was a terrible experience. Your whole body turned red-hot like an iron. Perspiration beaded on your forehead and trickled down the middle of your back. Maybe your breathing was easier, but the kerosene smell made you feel worse.

The next day at school, when the room warmed up, the remedy seemed to kick in again. You reeked of kerosene. Everybody knew who had taken a dose the night before. It was no secret.

◆ ◆ ◆

A tastier version that we preferred was to send someone down to the root cellar to fetch a batch of onions. Chopped up into small pieces and boiled down to a thick syrup, this was a much sweeter concoction that worked wonders on a cold.

Some people cooked onions down into a thick paste to use as a poultice on a wound. They would spread the warm paste on the skin, cover it, and tie it down with a piece of flannel.

Many mothers believed in the power of a mustard plaster to cure

a stubborn cold that had made its way to the chest. I remember watching Mother put a mustard plaster on my brother's back. This was in the mid-1920s. My brother was terribly sick at the time. Red-faced, tremulous, irritable, and burdened with a very high fever, he could hardly stand. Mother put the mustard plaster on him and led him to bed. The plaster was kept on for a certain amount of time, then removed.

He complained about how hot it got. He wasn't blistered by it, but if Mother had left it on much longer he could have been. It worked like magic, and Mother was very proud. I recall her telling a neighbor lady about it on the phone, and the neighbor responding that she had done the same to three of her kids the night before.

I was only seven or eight years old at the time. It was a great disappointment to me that Mother did not think I was sick enough to warrant a mustard plaster, too. I think I put up a fuss and tried to convince her I needed one. She promised that I would get one if I ever got a chest cold, but somehow I never got one serious enough.

◆ ◆ ◆

One old gentleman who lived in our town had lots of contact with Indians. He had grown up around them, and even lived and hunted with them. The Indians had a good deal of practical experience using native plants to cure various complaints. This old fellow knew how to make a tea out of the burdock root, or skunk cabbage, as we called it, to cure or prevent boils.

Such remedies were handed down from person to person. Each in turn developed his or her own opinion on a given cure based mostly on personal experience. If it was effective, they swore by it. But it didn't always work as well for the next person.

◆ ◆ ◆

Some people tried to ward off sickness in advance by wearing an asafetida bag around their neck. This was a foul-smelling, gummy substance made from some exotic member of the carrot family. The bags were supposed to be worn at bedtime, while eating or bathing, and even in church, despite the strong odor.

My mother's elderly aunt always wore such a bag. I remember Mother telling that when she was young, if her aunt came to visit, my mother always tried to hide and not come out. The odor was so powerfully disagreeable, Mother didn't want to go through the ordeal of being hugged. But people swore the substance kept them healthy.

Maybe it just prevented others from getting close enough to pass on their germs.

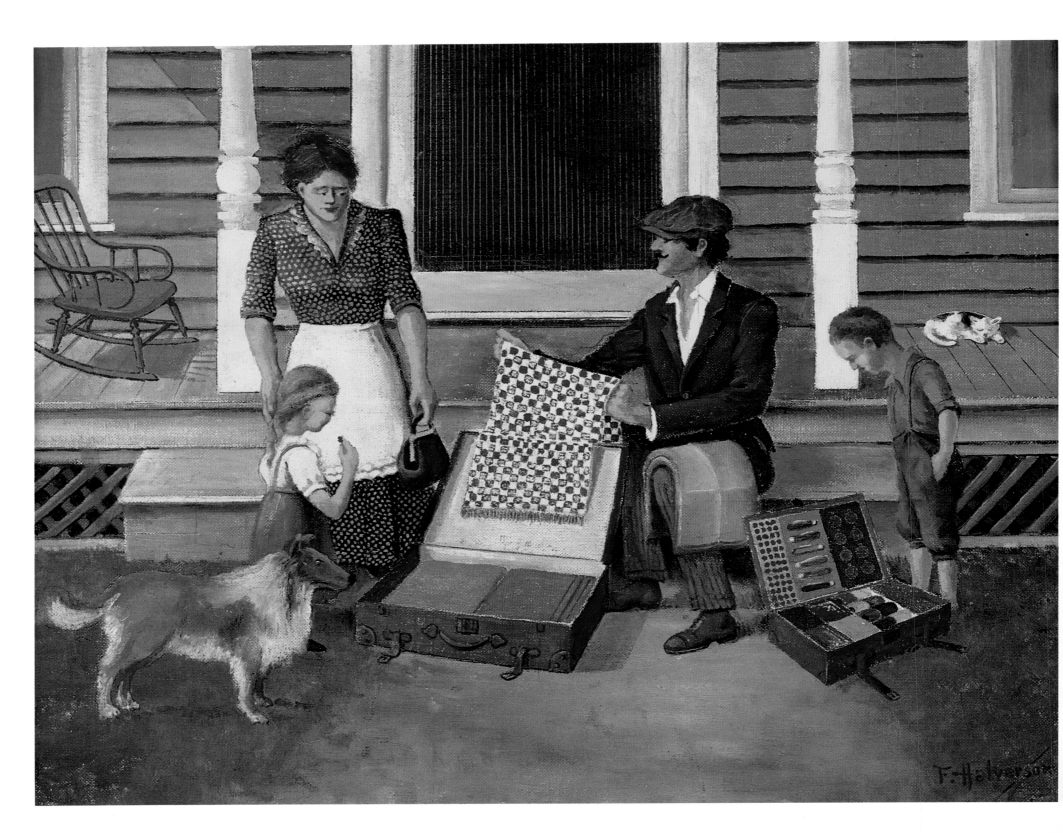

# Traveling Salesman

In the early days, traveling salesmen were welcomed by the farmer. Farms were many miles apart and far from any town, making it difficult for the lady to shop for things she needed. Here, the lady of the house has her purse ready to buy from the traveling salesman.

He's showing a bright set of towels from his suitcase, with more draped over his knee. The young boy seems more fascinated with the contents of the other suitcase loaded with pocketknives, watches, shave cream, furniture polish, and cologne.

The watches in the case resemble the gold one my dad carried in his watch pocket, a special pocket on the bib of his overalls. The watch was attached to a short piece of leather strap, so it was easy to check quickly and safely. The strap was made of tough cowhide we could buy at any leather store. The watch had a large loop over the stem that the strap was tied to. On the other end of the strap, Dad fixed a small harness-snap that fastened through a small factory-made hole at the top of the bib. If his watch slipped out of its pocket, it would swing on the strap and not get lost.

The little girl is enjoying a piece of red candy given to her by the man. Salesmen always had a piece of candy or gum for the kids. It was a tradition we came to expect. When we recognized the salesman's horse and wagon, or in later years, his car or van, turning in the front gate and bounding up the lane, we would come running to see what he brought as a treat.

The boy can hardly miss the board of gleaming pocketknives. It was an eye-catching display, to be sure. Every boy desired to have a knife like this. Then, you always had something fun to do. You could whittle, or just sharpen the blade. You could use the harness punch to make an extra hole in your belt — one you didn't really need, but it was fun, anyhow.

The painful part of seeing all the gaudy merchandise was figuring out how to pay for any purchase. In those days farmers had very little money, so the next best thing was offering grain, eggs, or sometimes chickens in trade. If it was about time for the new brood of pullets to start laying, the old hens were apt to be traded. Knowing that some of his best sales were the ones he bartered for, the salesman usually came prepared with crates, sacks, or boxes in the back of his vehicle.

The slim-nosed collie dog seems to be enjoying the procedure, while the cat is oblivious of the whole situation. When the salesman leaves, the dog will feel obligated to bark and chase the vehicle down the lane, out the front gate, and a respectable distance down the road.

While that goes on the cat will probably sit up, clean itself, yawn, then continue with its nap.

# Old Couple at the Rain Barrel

Resting in the shade on a quiet afternoon, two elderly people visit and work, surrounded by the old-fashioned implements they had grown up using. A wooden rain-barrel sits, mounted on two skids, against the house, with a downspout poked in it. A bucksaw and a plainly-made broom adorn the side of the clapboard home. Nearby hangs a long-bladed scythe. Its curved, slender blade smiles in repose, ready for the next harvest.

Green shrubs crowd the corner of the weathered house, reaching for the earth dampened by seepage from the wooden barrel. The old couple are immersed in a quiet time, peaceful in their concentration. Like many neighbors I knew, these older folks look like they are accustomed to working with their hands. When something needed repair, it gave them more satisfaction to fix it than to throw it away for something new.

The white-bearded gentleman is tying a rope on the bail of a small wooden bucket used to dip water from the wooden barrel for washing or cooking. When this region was first settled, access to a good supply of water was critical to the location of a house. In those early days, water was drawn by hand from a stream or spring, from a shallow surface-well, or from a rain cistern, and carried into the house. The pioneer farmers didn't want to carry their water any farther than necessary.

If they needed a well, they would try digging first before choosing a house site. Sometimes after excavating for several days they would have to give up and start over in another place. Various possibilities would be tried until a satisfactory well was complete, with plenty of water available.

Dipping water out of a cistern by the house was more convenient. Any source of water close to the house was welcomed. Some houses were fortunate enough to find a spring with especially fresh, clear water.

This sitting area looks like a favorite place. It is sheltered from the wind and partially shaded, but has enough light for the close work they are doing. The bright, clay soil is hard-packed from many steps each day. It is even possible the house itself has only a dirt floor. With few windows providing little light, this couple will do their work outside whenever possible.

The lady has her mending. While she concentrates, she may share a thought with the man or just hum a favorite tune. The snow-white fleece behind her is soft, cushioning the hard wooden chair whose uneven surface, like the rest of this simple lifestyle, is a measure of the caring hands that made it.

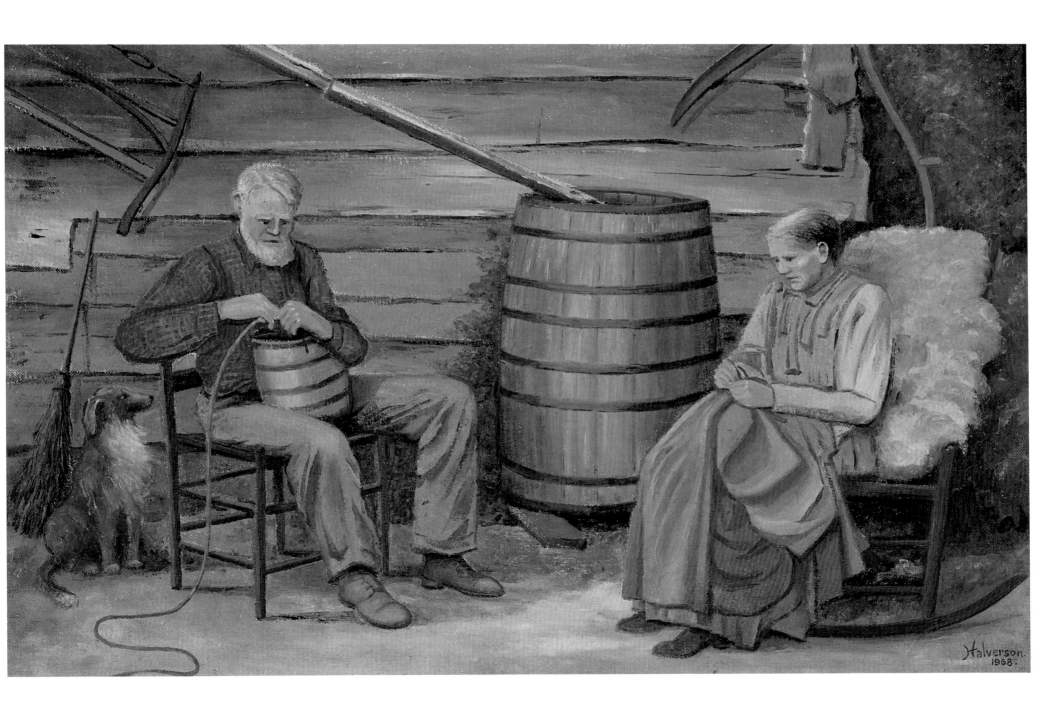

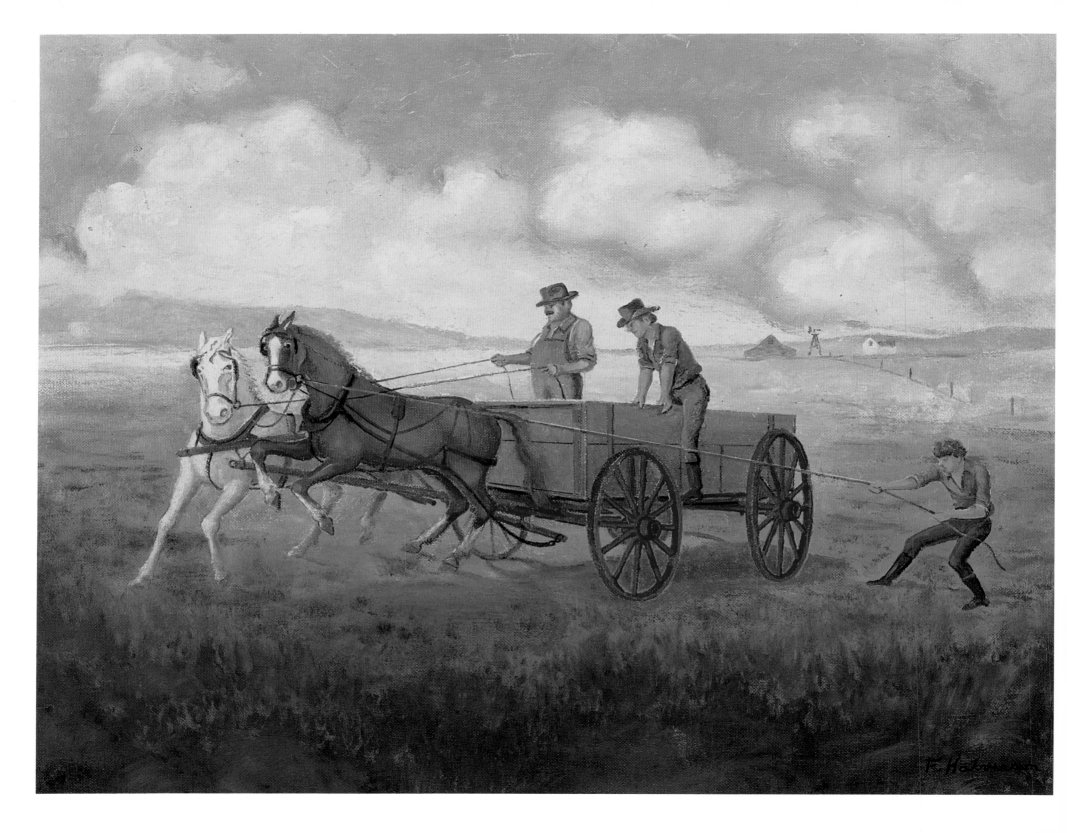

# Horse Breaking

Training a horse to pull farm machinery was a very important job. Occasionally, every farmer would lose a horse to sickness or mishap and needed to get a replacement from a local horse dealer. These dealers always had horses for sale or trade, trained or untrained. A well-trained horse was always more expensive. However, most farmers knew how to train their own animals.

Some farmers would attend horse sales held throughout the territory. In the early 1900s, wild broncos were caught out west and shipped in by railroad cars. There were always plenty of buyers anxious to pick up animals at bargain prices. Occasionally these shipments would include a few wild mules.

To domesticate these animals, trainers often resorted to using a trip harness, a contraption which allowed the trainer to trip the horse if it acted up. The horse was brought to its knees, helpless, until the harness was released and the horse allowed to get up again. After enduring this a few times, even the wildest horse generally became more cooperative.

Most farm horses, however, were raised locally and trained from birth. Little foals were introduced to the halter early in life. Later, they were shown the bridle and bit and learned to respond to the reins.

As time went on, a horse might be hitched to a wagon and taken out in a field. A plowed field was especially effective because the soft base would quickly tire a horse. Some farmers would hitch an unbroken horse in the center of a three-horse hitch on a disk and work him until he quieted down.

I heard one story of a farmer who tried to train a pair of half-grown wild mules. He was not their first owner, but the first had given up. The new owner coddled them and showed them great kindness. After some time, he put them in a light harness and led them to a small buggy.

He hitched them facing the barn, so they wouldn't run off before he could get in. They were tight against the barn, so he slowly backed them up, then pointed them down the lane. In a flash, the mules took off running with reckless abandon.

The lane had a sharp curve as it passed the house, then straightened out before joining the road. The buggy lasted until it hit the corner post at the gate, smashing it and dumping the helpless driver. The mules headed for the road, kicking up dust and rocks, dragging the remnants of the buggy. Very little of the buggy made it to the gravel road, where the mules stumbled and turned east. After another half mile they turned north, then west, then south, until they circled the section and were headed back up their home farm lane. Stubbornly, they still dragged what was left of the busted buggy.

Tragically, coming full-speed into their own yard, they spied a small open door to the barn and made a bee-line for it. There was not enough room for both to enter, and when they hit the doorway at the same time there was a tremendous crash. One of the mules was killed instantly and the other, injured, had to be destroyed.

Mules were very set in their ways but if properly trained, they were strong, smart, and as efficient as horses. They wouldn't over-eat or, even on hot days, drink too much water. Many farmers kept at least one team of mules and never had cause for complaint.

The beautiful sorrel in the painting doesn't look very happy in the harness, with two men holding him. He is hitched to a double-box wagon which is light and easy to maneuver. This wagon won't make too much noise and won't run up on his heels and frighten him. The sorrel looks high-spirited and flighty, like he wants to run. To break him of this, the man holding the tether will keep the wagon going round and round in a circle until the horse gets tired.

# Barn Raising

Raising a barn was a challenging task, but people made it a joyous time. It took a lot of teamwork. People from miles around responded, bringing their own tackle and other equipment needed. The framework was assembled on the ground, then lifted into place with ropes and gin poles. Women and children brought food, did the cooking, and helped in any way they could.

First, the site was cleared. Some sections of the prairie were terribly rocky. Large rocks needed to be removed with pickaxes, shovels, and crowbars. Smaller rocks were saved to build the foundation. Skilled builders used as little mortar as possible to build a solid rock foundation that would outlast the barn.

The wooden beams were trimmed with two types of blades: a narrow-bladed ax for chopping into the wood and a broad-bladed ax for smoothing out the beams laterally. To join the beams, they drilled holes with a big auger and used pegs instead of spikes or nails. In the painting, they are lifting a large frame with ropes and gin poles — raising a "bent," as it's called. Four bents made the main structure, with more needed for a complex barn.

A well-built barn would stand for generations. I remember one such barn that was twisted and damaged during a tornado in 1936. A smooth-talking mechanic talked the owner into letting him try to straighten the barn with only three or four car bumper jacks. He placed the jacks around the structure and pumped the handles. Nothing happened. Several days stretched into two weeks. The bumper jacks just didn't work, and the mechanic made himself scarce.

The farm operator, who was renting the place, called in an older fellow. This contractor was retired but had built a lot of barns in his day. After some examination, the old builder pointed out a dozen strategic points to apply more powerful screw jacks to the twisted structure.

The farmer followed his advice and straightened the barn. It still stands today, doing the job it was built to do.

After raising a barn, many times a dance was held that very evening to celebrate the new barn's completion. As the evening drew on, the moon rose, spreading its reflections on a happy crowd. A dewy dampness clung to the acres of grain and pasture nearby and wafted in to the high-stepping dancers. The smell of new lumber and fresh shavings hung in the air, a fragrance as refreshing to a farmer as apple blossoms brought into a farmhome to grace a fireplace mantle.

They made music with a zither, a violin, a clarinet, and a time-keeper who tapped on a homemade drum, spelling out the cadence to dances like the waltz, the schottische, and the two-step. When late in the evening, the band played "Home, Sweet Home," the crowd moaned with unhappiness until the band was convinced to play just a few more.

Later, some barn owners held commercial dances in their barns, charging a small fee and hiring a band. Even in the Prohibition days, distilled alcohol was readily available at these events. Some carried a thin flask in a hip or shirt pocket. With a "yup" of the cork, and a soft gurgle, heads would turn as someone took a quick slurp from his private stock.

As dances got bigger, security was hired, usually one or two big fellows whom no one wanted to cross. I recall one such gentleman who wore a captain's cap with a shiny medallion labelled "Chief" sewn on the front. The cap was just big enough to cover several small bottles, tucked under his cap, resting on his large head. He was busy all evening, providing security and more. When he was out of merchandise in his hat, he would make a quick trip to his car.

Barns were available for dancing mostly in the summer. By late fall, they'd be full of stored hay and grain. But by next mid-summer they were empty again, ready for another season of dances.

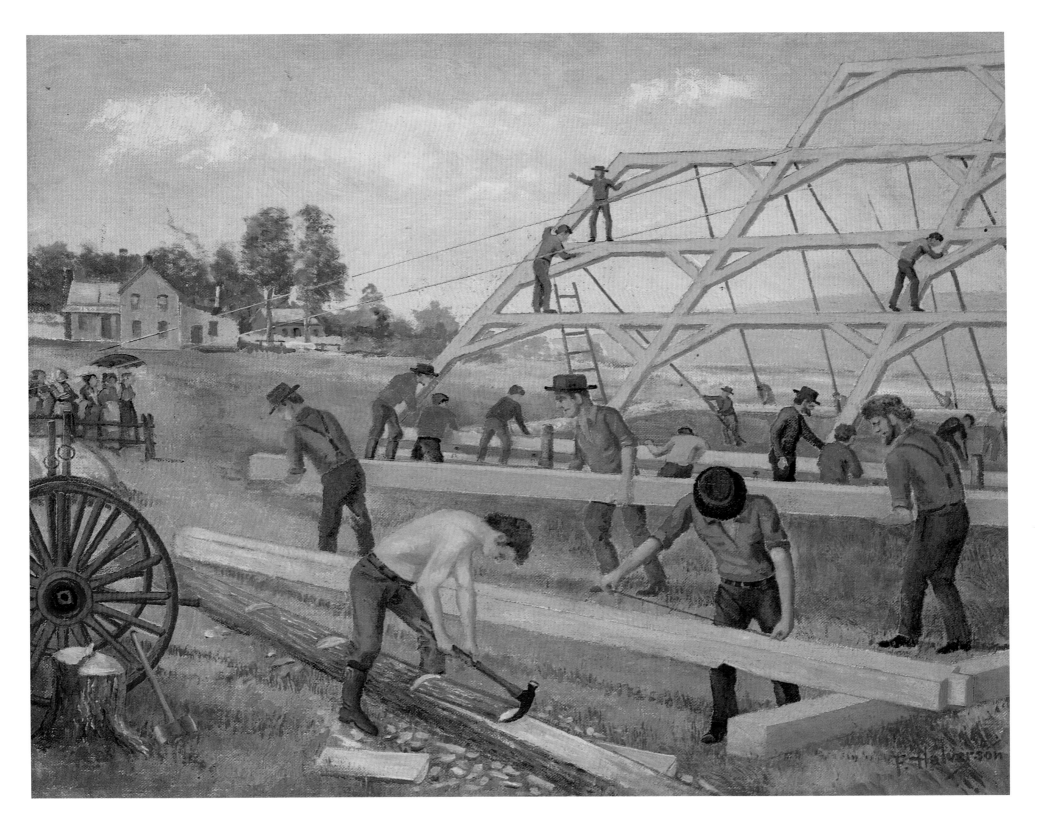

# Harvest Time

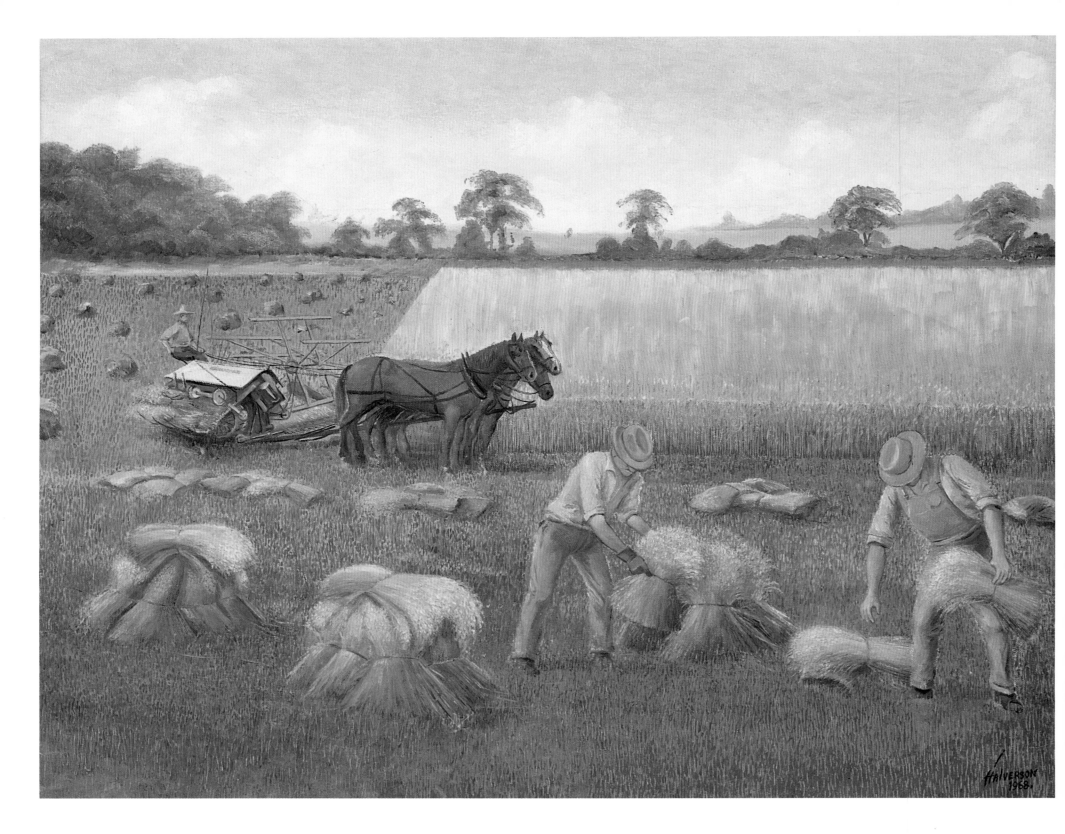

# The Oat Harvest

Older farmers looking at this picture will give a sigh of relief that they aren't bending over, grabbing these bundles and standing them up into shocks. In July, most grain fields were golden and the harvest was underway. The hard work of cutting and shocking had begun. This scene was played over and over, each year, throughout the early 1900s.

A three-horse hitch is pulling a McCormick binder through the field. This machine cut the grain, sized it into a bundle, bound it with twine, and kicked it into a bundle carrier. At intervals, the farmer dropped three or four bundles at a time around the field. Each time he came around, he made his drops adjacent to the piles left on the previous round, making windrows. The men doing the shocking set up the bundles into shocks.

Later, when it was time to thresh, the experienced horses would follow the rows of shocks. The men pitched the sheaves onto their bundle racks and hauled the grain to the threshing machine.

Oat shockers generally wore gloves, as the twine strings were very rough. Otherwise their hands would be very sore after grabbing bundles all day. They also wore hats of felt or straw to keep off the sun.

To make a shock, a fellow usually took two bundles by the twine and stood them up against each other. He then balanced two more alongside of the first pair, being sure to keep an air-passage open.

Then two more were stood upright, the shocker making sure he still had good circulation through the shock. Then he laid another bundle against each side. This made eight bundles, four against four. A ninth bundle, called a cap, went over the top, with the sides pulled down over the shock.

There were usually nine bundles in a shock. If the straw was heavy, some farmers made seven-bundle shocks, including the cap. The shocks allowed the ripe grain to dry, while going through a "sweat" or curing process, and to shed any rain showers. Meanwhile, the farmer waited for the threshing rig to come to his farm.

Shocking small grain — oats, barley, wheat, or rye — ranked near the top of our lists of the hardest work on the farm. Corn picking and silo filling were hard, too, but some of the hottest days of the year occurred during the small-grain harvest. For this, thirty cents an hour was top wages. A hired man was much admired if he reached the coveted wage of $3.00 a day.

If the binder broke down, it always seemed to happen in a low spot in the field where there was no breeze. The sun was high and bright. The horses would stand quietly, panting and stomping at flies. As a young boy, of course, I wanted to help fix the machine. More than once I touched flat surfaces of the binder, or picked up a wrench that had been lying in the sun, only to pull my hand away quickly. The metal was very hot. After that, I got out of the way. It was one of the hard lessons a young farm boy learns.

Some fields would have a low part where water would gather after a rain. Before drainage tile was put in, such fields were subject to flooding and often the crop in that part was never harvested. By the time it was dry again, all the grain had dropped off and only the straw would be left standing.

# Threshing

This painting depicts an old-time steam rig with great clarity. Important controls, carefully watched by the machine's operator, are shown, such as the gauge showing the water level of the boiler. If the water got too low, a soft-metal plug would melt, channeling the steam into the firebox. This put the fire out and prevented an explosion.

The pop-off valve served to relieve the boiler if it built up too much steam. A governor to control the engine's speed is perched up front in plain sight. Within easy reach are brake-control levers and a lever to release steam into the cylinder that propelled the big engine.

Other valves and piping were located strategically over the engine. A coal tender hangs close by with a shovel placed against it.

Hauling water to a steam engine was a young farm boy's greatest dream. Water was taken from nearby rivers, streams, shallow ponds, or surface wells. On some farms, a source of water could be some distance away and of poor quality. Foreign materials would clog up flues and safety controls. Fuel and clean water were two important ingredients that kept those old engines puffing. Some of the engines held 95 gallons of water and 1200 pounds of coal. It required strong arms and back to pump that much water by hand.

Two threshers and the engine man are enjoying a mid-afternoon rest by the engine's huge wheel. They both have their hats off, relaxing in the cool shade. The youngest thresher and his collie dog are resting, too. The man unloading the bundle wagon, filled high and square, is keeping the threshing machine running efficiently. The fancy, high-stepping team pulling in to unload is covered with a light canvas, possibly as a protection from flies.

From a flywheel on the steam-engine, a long belt reached to the nearby separator. This machine was called a "separator" because it separated the grain from the straw. Here, a cylinder turned and the bundles of grain were pitched into the machine and gobbled up. Straw was blown out, and the loose kernels of grain were elevated to a high point on the machine, then augured into a wagon.

Some farmers sacked their grain as it came out, but in Northwest Iowa we generally poured it loose into a triple-box wagon and hauled it right to a farm storage bin or a grain elevator in town. With a box 36 inches high, each wagon held 72 bushels of grain when full.

Many farms were rented. Renters owed their landlords one-half of their corn, and two-fifths of their oats. The landlord's portion usually went right to the grain elevator for storage.

A threshing run was formed when a group of a dozen or so farmers pooled their dollars and set up a run. The run operated on shares. Each farmer was charged one to two cents per bushel to thresh his grain, with the rate set in advance at an annual threshing meeting. Then, after the run, each farmer received back an equal share of all the profits, after expenses, involved in operating the entire run that year.

Sometimes the farmers bought a full rig, separator and steam-engine. More often they bought just a separator and hired someone who owned a steam engine to pull their machine. One year they would start at one end of the run and alternate each year thereafter.

Other farmers just hired an outside custom-operator to do their threshing. Those fellows stayed busy through early fall.

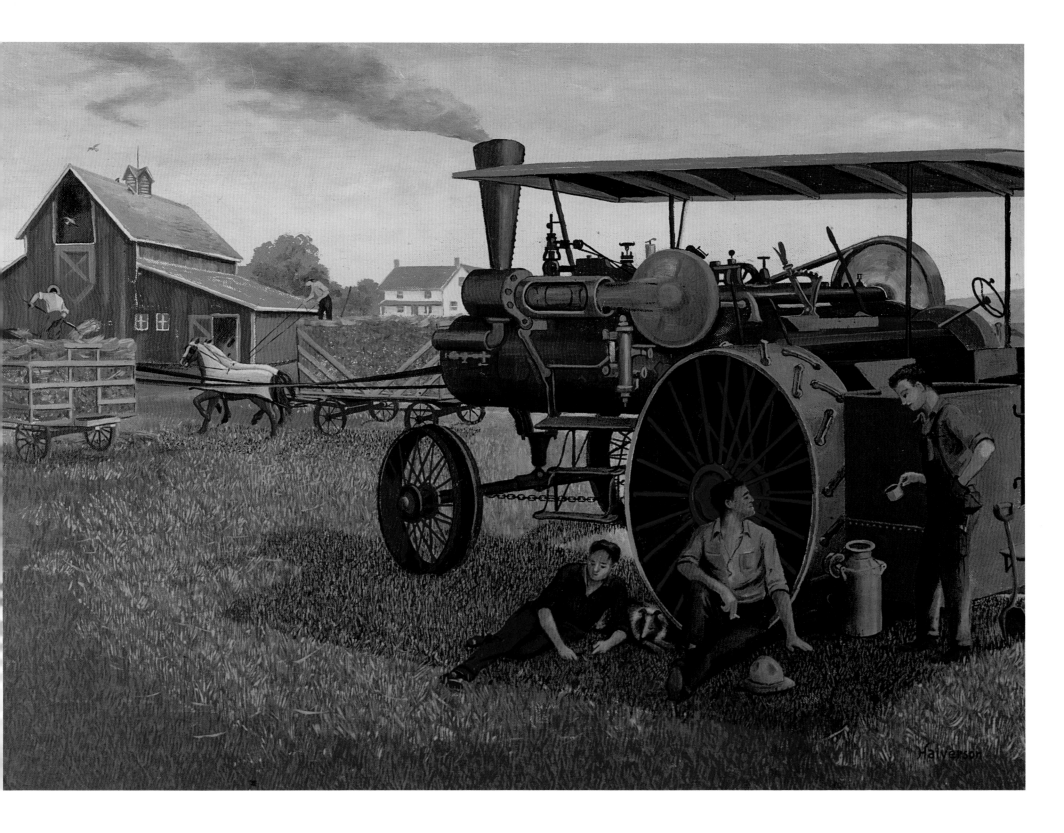

# Quitting Time

Threshing time was in mid-August. After a long day, evening shadows lengthened. Threshing was over for the day. The last bundle rack had been unloaded, and the threshing machine's metal cooled. With empty racks, each neighbor headed down the lane, some with several tedious miles to go before they got home.

At home, farmers watered and fed their teams, and got ready to do their evening chores.

During the day a strong southwest breeze had wrung every last drop of moisture from the soil and straw. Now, as the sun drops low, a light, cool zephyr touches the cheek and dances across the meadows beyond the barn.

Bridles jingle as the team at the water tank stands peacefully, while the farmer ties the reins and loops them over the top of the hames. The horses will enjoy their drink of fresh, cool water. Trace-chains sing as another pair of horses climbs the incline toward the barn.

A fairly new straw pile shares the skyline with the barn. This straw pile might have been threshed out several weeks earlier at the beginning of the neighborhood run. The white-faced Hereford cattle have been nibbling their way into it from all sides.

Cattle were especially keen to taste straw which often had many small oats, called pin oats, mixed in. These smaller kernels of grain were so small they were blown out with the straw when it was threshed. The cattle would munch away at the sides of the stack. Sometimes they would burrow tunnels right into the stack, which could collapse on them. Smaller calves might be trapped and lost to suffocation if this occurred.

As the setting sun slips behind the barn, shadows grow longer. Soft, cool breezes flow from a lower pasture, smelling of goldenrods that thrived along the banks of the creek. With a loud smack-smack of wings — like pigeons when they take off from a barn — several big birds pass by. With a whipping sound, the big wings settle, then, after a pause, comes the shrill gobble-gobble of a turkey.

Several gaunt turkeys strut on top of the straw pile. Although wild turkeys roamed in wooded areas with plenty of water and cover, some farmers kept domesticated birds. They took about the same care as chickens but needed more room. The ones raised on a farmstead were allowed to roost in trees, on buildings, and on the straw pile.

The August sun dies in a conflagration of radiant reds. Welters of gold explore the fringes of the central brilliance. Night birds twitter or call shrilly in the grove in back of the house. The cows stick their long necks through the loose wire-fencing and grunt, sensing it unusual to be milked so late.

On days we threshed, chores were never finished until after dark and beyond. But there was always a lingering glow of soft colors to stain the western skies as the last cow was milked and turned out to graze on the damp, sweet grass.

The next brilliant, sunny morning we would gather again to finish

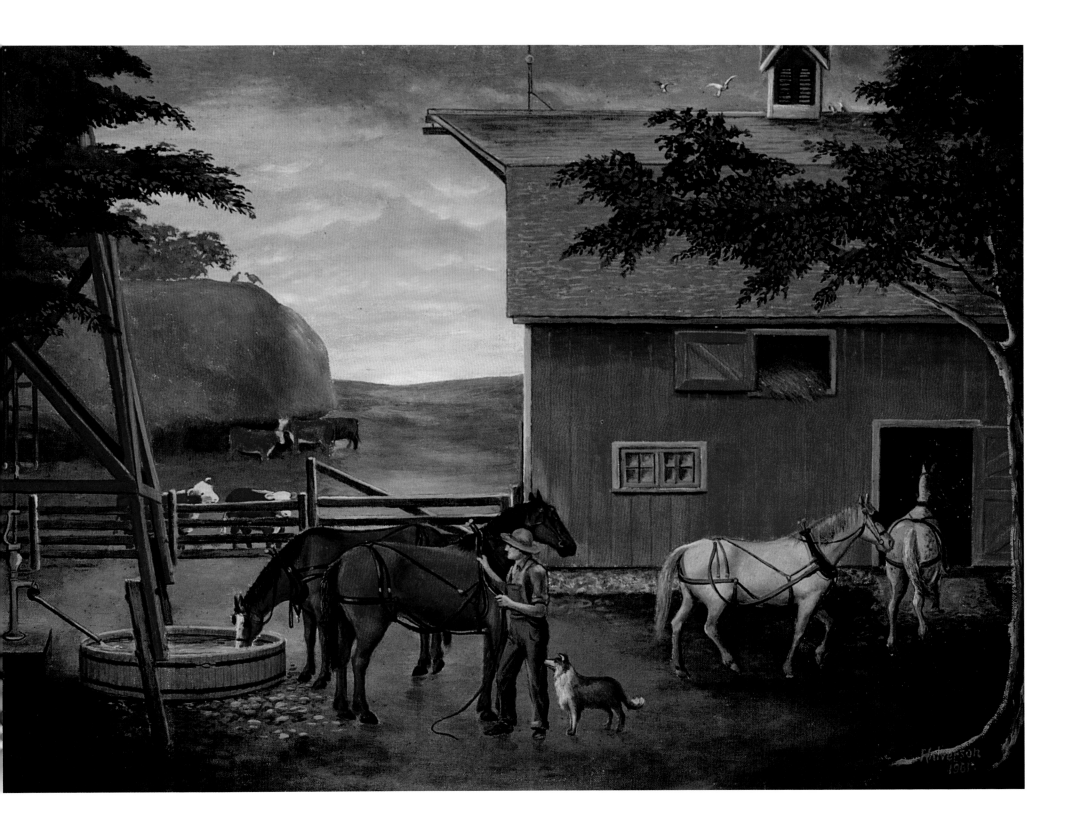

the threshing. The machinery rattled to a start, and the bundle-haulers laughed as they headed for the field for the first load of bundles.

In August, if we had cool, wet nights, threshing might start an hour later. If the machine man forgot to tell everybody what time threshing would start, a flurry of phone calls were made to tell the men when to come. The damp straw would be tougher and wouldn't thresh out all its grain.

◆ ◆ ◆

Though seldom a big cash crop, the oats we harvested in the early 1900s were mostly fed to chickens, pigs, cattle, and horses. The oats fed to draft horses provided the power to operate the machinery on the farm. The oat-straw, besides being used for feed, was also used as bedding for every animal on the farm. Afterwards, the used bedding-straw, spread back on the land, made good soil and carried lots of available nitrogen, phosphate, and potassium.

The oat crop also made a good nurse-crop for clover that was planted at the same time and matured the following year for pasture and hay.

◆ ◆ ◆

After the threshing run was complete, it was a mark of a good farmer to haul manure that had accumulated out to the field to cover up with the fall plowing. It was time to get five or six of your best horses ready. Plowing a field in the fall, to be planted to corn the following season, made it easier to work the next spring. Compared to spring plowing, fall plowing created a field that was softer, with less chunks, and held moisture better.

Using a gang-plow with two or three mall-boards, we would step off sections about thirty steps wide across the length of the field, leaving flags to mark the width of each "land" uniformly. A land was a section or chunk of the field you wanted to plow. You would divide a field up into several of these lands, and then plow them one at a time. The first furrow through the field was called a back furrow. The last furrow of a finished land is a dead furrow.

◆ ◆ ◆

Oats were usually planted early the next spring, in late March and early April, in cool, damp ground. Sometimes only days before, the land had been covered with snow. It was important to prepare a good seed-bed. Cornstalks left standing in a field were first disked under, then oats seeded, and then the field was disked again. Some farmers spread their seed first and disked twice.

Either procedure leveled out the small draws and ditches. The seeder spread a good pattern, and the seed oats disappeared in the creases and cracks. Older farmers will recall stopping their team and checking their broadcast seeder by looking in a few hoofprints of the horses in the soil. If they saw roughly seven to nine kernels lying in each print, they knew they were seeding the right amount — about three bushels per acre.

When the seed was in place, the field was harrowed, covering up the seed that otherwise was exposed. The finished field had a smooth, barren look. A neighbor once looked out over his newly seeded and harrowed oat-field and said, "It looks so arid a jack rabbit would need to pack a lunch to get to the other side."

It was rare for a farmer to seed the same amount of oats as his neighbor. Some seeded the smallest amount they could get by with. Others, imagining a great return, would seed too much. If you planted a lot of oats, you might end up with too dense a crop. In a dry year, a heavily-seeded crop could run out of moisture before maturity and lose quality and yield.

# The Corn Picker

Before the days of the mechanical picker, corn was picked by hand. Most farmers liked to be picking corn by early dawn. In the hush of a quiet early morning, when the wind was calm, you could hear a steady thump of yellow ears hitting bangboards and dropping into wagons. Farmers throughout the whole community joined in the crescendo of the harvest.

There were many cold mornings for corn pickers. Frost would cling to the shucks. As the temperature went up, snapping the ear from the stalk sometimes became tougher. The picker most always wore mittens or gloves. On these mornings they got soaked, and stayed that way for an hour or so. On bitter cold days, a picker would carry several pairs of gloves or mittens, alternating back and forth between the two pairs as he worked.

Most farmers also put on extra sleeves, made from heavier material with elastic on both ends, that slipped over their regular shirt sleeves. These protected the everyday shirt underneath.

On one hand, corn pickers wore a metal hook riveted to a leather strap. There were various options, depending on individual preference. Most chose either a thumb hook or a palm hook. The hook was strapped on over the glove or mitten. The thumb hook lay about halfway up your thumb at the first joint. The palm hook was strapped on to rest on the heel of your hand.

The corn was picked and husked with a few quick motions. For a right-handed picker, first you grabbed an ear of corn firmly with your left hand, toward the tip. Then, with the right hand, you raked the hook crossways across the ear around the middle, pulling loose about half the husks and revealing the dry kernels. You then grabbed the bare ear with your right hand, and pulled back the rest of the husks with your left. You snapped the ear from the stalk with your right and tossed the ear back-hand — usually without looking — up and against the bangboard of the wagon so it dropped inside the wagonbox.

The experienced team of horses learned to keep the wagon within easy pitching distance. They walked very slowly, straddling a row that had already been picked. Still, the horses often managed to find an occasional ear that had been missed.

In the painting, the wagon box is nearly full and the corn is piled

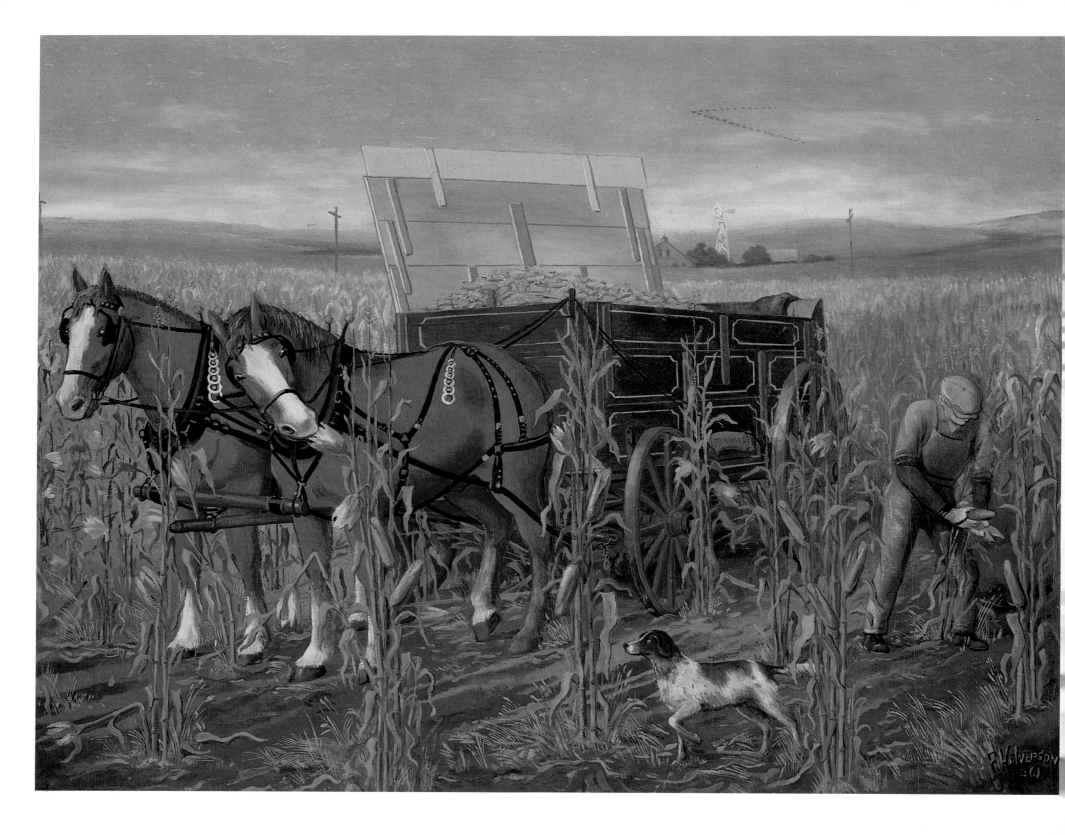

up against the bangboard. An extra board could be slipped onto the top edge of the wagon box, giving the farmer extra space to continue picking.

The corn we grew before hybrids was called "open pollinated." In those days, forty bushels per acre was a good yield. It was not until the mid-1930s that hybrid corn, bred to withstand drought, diseases, and pests, became popular. More uniform, this corn was easier to harvest by mechanical methods. The development of hybrids increased production by over one half.

◆ ◆ ◆

Corn was picked in all kinds of weather. Many older farmers maintain that picking corn by hand was the toughest job on the farm. Others claim shocking oats, or hauling bundled corn to the silage cutter, was harder. Those jobs were tough, but neither lasted as long as picking corn by hand.

There were many corn-picking contests across the region. Fellows from all over the Corn Belt would congregate to see who could pick the most corn in a designated time. Each contestant's result was measured by weight. Judges checked for ears left on stalks and shucks left on the ear. Thousands of people would gather for some of these contests. Politicians expounded their qualifications to the crowd as farmers nodded, expectorated, and kicked dirt, impatient for the contest to begin.

◆ ◆ ◆

Recalling those days of corn picking, every older farmer will remember the tortured squeal of a heavily-loaded wagon rolling in from the field on uneven, frozen ground. At the corn bin, Father would ease the team closer for unloading. A shiny scoop-shovel hung close by, cold and frosty to the touch. The team was tired and anxious for a drink at the stock tank.

I can still hear the familiar bumps and clicks as the shovel-board is let down. That was a small platform at the back of the wagon on which the farmer could stand to scoop off his load.

Squash and pumpkins were sometimes planted in a specific area of the cornfield once the corn was up and growing. The seeds were planted at the base of the corn plants and cultivated at the same time as the corn. A wagonload would come in from the field, heaped high with corn and rounded off with multitudes of squash and pumpkins.

# Shocking Corn

It looks like a warm, mid-September day. The ears of corn would still be drying, with little dents forming in the ends of the kernels. A farmer always hoped to shock before the first frost so that the cornstalks would still have their full nutritional value.

Corn was shocked for the cattle to eat — stalk and all — as winter feed. This was an important part of the animals' diet, just as silage is now. Corn shocked in the field had very little spoilage. Only if it rained and the field flooded, getting the ground so wet that water soaked up into the shock, would the farmer possibly have problems with mold. Livestock thrived on the good fodder.

The corn shockers have rolled up their sleeves for the harvest. One of the farmers is on his knees tying a bundle of corn with twine, while the older farmer waits to stand the bundle against the already-started shock.

They are shocking with the help of a "horse." The shocking-horse was used in the early 1900s before farmers acquired mechanical cornbinders to cut and bundle cornstalks.

In the springtime, corn was planted in a regular checkerboard pattern. Three kernels were dropped in each "hill," with the hills spaced three feet, six inches apart along the row. The rows were also planted the same distance apart, creating a grid of growing plants.

In the fall, each shock was built from cornstalks cut from a patch twelve hills by twelve hills square, or 144 hills of corn for each shock.

The shocking-horse was like one half of a saw-horse. The top crossbar ran seven or eight feet through the shock and bent down to the ground. It was about three feet high at the end. The corn didn't grow as tall in those days before modern hybrids. The crossbar had a hole drilled through it in the middle. A removable iron rod was placed through this hole, sticking out at right angles to the main wooden bar.

To start a shock, the farmer cut some hills of corn and laid them in all four corners of the intersection of the crossbar and iron rod. He tied this first batch together with twine, close to the top, then pulled out the iron rod. He then leaned the rest of the loose stalks around the initial group of stalks and the horse.

When the shock was done, he tied the stalks snugly around the middle. Finally, the horse was pulled out easily and moved to start another shock. A hard-working farmer might get twelve or fifteen shocks done in an average day.

Without a horse, the resourceful farmer devised a different way of building a shock. He took four hills of corn, forming the corners of a small square, and tied them together at the top without cutting them loose at their bases. Then he proceeded to build his shock around that.

This farmer has easy access to his cornfield from his barn. Several cattle graze nearby. The two dogs have trapped a gopher under one of the shocks and are starting to dig to force him out.

Trees adorn the gravel lane that circles the barn and hog house. With colorful foliage of yellows, orange, and pale green, they are ready for some cold weather. A plum thicket reveals its fall colors, too. The long days of winter are soon to come.

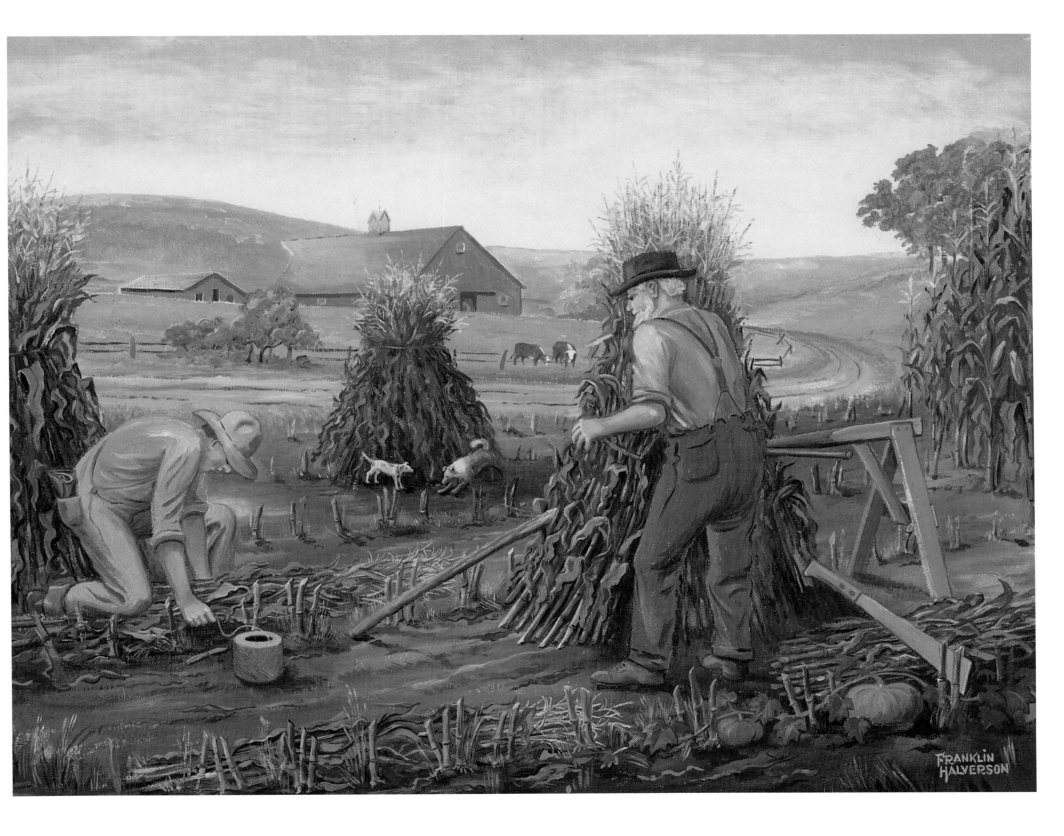

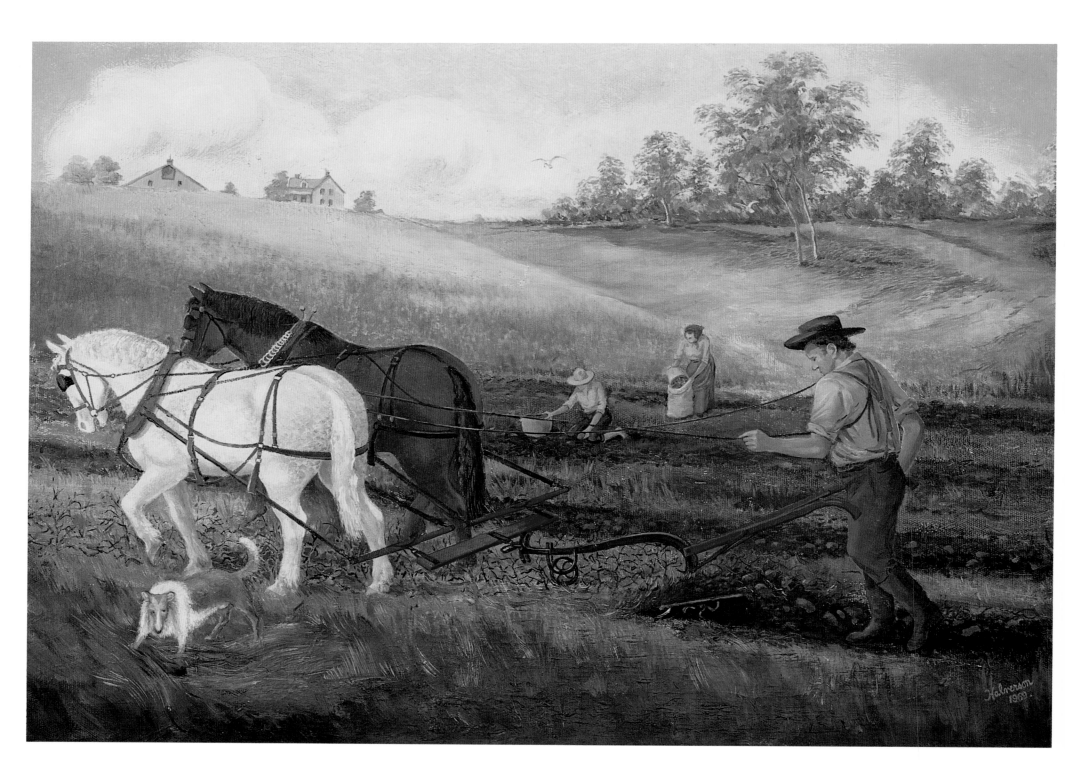

# Digging Potatoes

The trees are turning their fall colors, glossy yellows stained with the original greens. Reds mingle on the spindly white birch. A stand of young trees shelters a briar patch that grows close to the long lane. The house and barn, peeking over the hill, look down on a family potato-digging operation.

My father would pick a Saturday when all the kids were home from school. We usually used a double wagon-box because, with its low sides, we could dump our buckets easily and hurry out to fill them again. This family is sacking their potatoes, leaving the sacks to be picked up later. A farmer might choose to sack half the potato crop to sell, and put the other half away loose for the family's use.

Most homes had a potato bin where fresh-dug potatoes were stored. The dark, cool bin was usually in the basement. My father thought there was less spoilage if the crop was stored loose in the bin. Even though the bins were dry and cool, the potatoes would sprout. It was my job to "sprout" potatoes. This was a dusty job. I sorted and tossed the bad ones and rubbed the sprouts off the good ones. The sprouts would get long and white, and I would throw them in with the spoiled potatoes. The chickens or hogs would get a mid-winter treat.

The seed potato was sometimes taken from last year's crop, or the farmer planted a certified seed, free from disease and true to type. The painstaking job of cutting each potato by hand, into quarters or smaller, took many hours. I was glad the year my father borrowed a potato seed-cutter. It was operated with a foot pedal. The pedal brought a grid of knives down upon the potato, lopping it into several pieces. With one hand you swept the pieces into a bucket, while the other hand laid another potato on the stand. You pushed the pedal as soon as your fingers were out of the way.

The picture shows a heavy, black soil in which the potato plant thrives. The farmer is using a potato-digger plow. The moldboard was an inverted 'V' blade that let the dirt flow over it onto a slatted apron, which was hooked to a ground-driven vibrator. This bounced the dirt loose from around the potatoes and deposited them above ground.

The horses seem to know what's going on. They are following the row closely and keeping the doubletrees even. The collie dog is busy trying to corner a fat gopher that has slipped away into his burrow.

Large fields of potatoes were planted with mechanized potato planters. Smaller plots were often planted by hand. I can recall my father making a furrow with a walking plow. My older brother followed behind barefoot, carrying a bucket of cut potatoes. He would drop them one by one and step on them to plant them firmly. The soil was soft and easily worked, making a good bed for the potato crop. Then Dad would come back along the row again with the walking plow, covering the newly planted potatoes.

My first introduction to growing potatoes was the summer my father ordered me out to the garden with him. He found a bug about a half-inch long and said it was a potato bug. It had five black stripes with a yellow background and looked ugly.

He gave me a tomato can, one-quarter full of kerosene, and showed me how to pick the bugs from the leaves and vine, drop them in the kerosene, and go on to the next plant. My older sister and brother were pulling bugs too and it was a race to see who got the most bugs in their can.

# Harvest Moon

On a cool, still evening the last corn shock was tied. Rows of shocks stood like sentinels, relishing the last beautiful rays of sunlight from a Northwest Iowa sunset. A rich gold hue illuminated the western sky, deepening into a welter of rose and fiery red as time elapsed. The stain of reds, yellows, and orchid lingered, as the smell of fall slipped across the field, seeping into all the low places.

Currents of cool air swelled over hills and shocks. A smug patch of orange crept along the crease of eastern sky, becoming the top rim of a moon that rose, then slid behind white fleecy clouds, casting eerie shadows among the stand of scrub-trees.

Pumpkins, the plump symbol of fall, rested throughout the field in rows of corn and along fencerows. It's Indian summer. After several wintery days, these warm days in late October and early November were much welcomed. We all knew winter's blast would soon take hold. For the farm ladies, it was time to get ready for the local church bazaar.

◆ ◆ ◆

A bazaar was a marketplace for gossip and goods. The first church bazaars I remember were to raise money to pay our minister's salary. Three hundred and fifty dollars seemed a nearly impossible sum, especially during the Depression, but that was what the main office required for his year's keep. Our little town of Gillett Grove had to have a minister to lead us in our spiritual lives, so the ladies went to work — quilting, sewing, and planning a supper.

Individual groups of four or five women would call and talk on the party line, making arrangements to start their quilts. They pooled their money equally to buy material for the quilt and sometimes lumber for a frame. They used a frame to stretch the material tight, keeping it smooth while they stitched their fancy designs into the pieced coverlet top.

A quilt was made in three layers: a colorful top, a plain back, and an inner batting for extra warmth. The small stitches that quilted the layers together served to keep the inner lining from slipping.

Colorful geometric and flowered designs were traced over the material with a soft-leaded pencil. They might even sew random

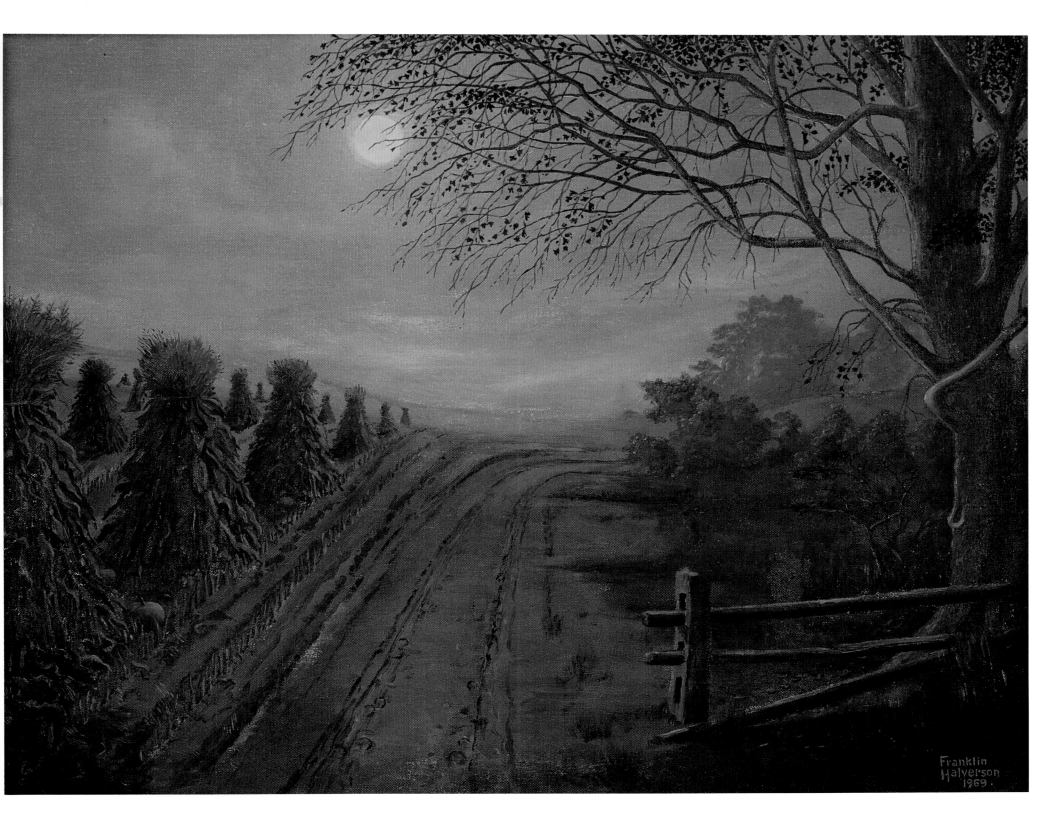

pieces of fabric together helter-skelter and call it a crazy quilt.

As early as I can remember, my mother always belonged to the W.S.C.S., or the Women's Society of Christian Service, a long name for the Ladies' Aid Society. This group kept things humming financially with soup suppers, bazaars, and community organizing every year. In little towns and country neighborhoods, these ladies were the spark when things needed to get done.

Every fall, for a period of over a week, one room in our house was taken up by the quilt frame. We had the luxury of having a larger house than most. Consequently, Mother always volunteered one of the rooms. She set up four or more chairs, sometimes two at a corner, and the four corners of the frame were clamped to these chairs. At mealtimes then, when we all sat down to eat, we were short one chair and I was placed on a stool instead. Being the youngest at that time, I thought it was a mark of great distinction to get the special stool.

For the quilting gatherings, the ladies who came usually had kids, too, and brought them along. Three or four of us would choose up sides and play war. We'd sneak under the frame of the quilt and build a fort. It was alright until we started to wrestle. The ruckus was quickly stopped by the ladies, and we'd scatter. Often we were bribed with cookies and lemonade to stay out of the way.

Other homes were busy, too. Some women sewed aprons and pot-holders. Others crocheted tablecloths and doilies. Hours and hours were spent sewing, crocheting, and quilting to raise money. One lady in particular always brought a beautiful handmade tablecloth, a different design each year. She started soon after one year's bazaar and laboriously worked all year until the next.

◆ ◆ ◆

When the auctioneer was introduced to the crowd, the hum of visiting quieted. Only a baby's cooing, relishing the end of his bottle, could be heard, and then the tiptoeing of somebody coming in the room late. A door slammed, and then quiet applause lightly echoed through the tightly-seated group. He thanked the ladies for his free supper and started the auction.

All of the assorted smaller items were auctioned first, leaving the fanciest work for last. Handmade ladies dresses and baby clothes were sold. Then, as they worked their way to the tablecloth, even we children stopped playing to stand around and watch. "Was somebody going to pay thirty dollars for a tablecloth again, like last year?"

Ladies sat, their eyes following every move of the auctioneer as they waited for him to come to the item they wanted to bid on. During the Depression days especially, the church bazaar was one of the few outings of the year that ladies were determined to buy something if they could. In most households, pennies and small change were hidden in safe places all fall, guarded carefully in anticipation.

Some men came just to indulge in the donated food that always tasted so good. They sat, their hunger satisfied, toothpick in hand or mouth, smiling as the auctioneer rattled his song, praising the beauty of the goods to be sold.

"I've got a nickel, let's make it a dime. I've got one dime, who'll make it two? One dime, who'll make it two? That's two dimes, can I get a quarter? Just look at this fine work! Hey, thank you ma'am. Now! Who'll give 30 cents?..." And so went the poetry of the sale.

The single stove in the church slowly cooled. People shivered a little as the room chilled, then we heard the rattle of grates as several chunks of firewood landed in the deep firebox. The crackle of the fire resounded, and soon the outer jacket of the stove grew a pale pink. People loosened their coats and jackets, and we got on with the concentration of the sale.

Outside, we heard a cough and then a cackle of a Model T Ford. With a quick scramble, we kids peeked out into the churchyard. The dim light at the entrance illuminated a long line of square, cloth-topped Model Ts and the shadows of wagons and buggies, hitched to nervous horses. We saw several "T" owners jacking up their rear wheels and warming up the engines. Intense cold had slipped in over the past few hours. Horses tied at the hitch-rail sawed their heads and whinnied

softly, surging against their halter ropes.

The car owners slipped back inside, knowing their cars would start when the sale was over. Neighbors nodded and whispered to the returning men, "How cold is it?" Still, three items remained: the beautifully crocheted tablecloth, a thick crazy quilt, and a spectacular rag-rug with brightly-dyed material.

Bid-takers searched the crowd, examining faces to see who might be interested. Tension built and the auctioneer pointed at the crocheted tablecloth. The bids came in and the music of his voice delighted the crowd. His bid-takers responded to each wave or nod, and finally they knocked it off... to the same gentleman who had bought the one last year. The crazy quilt and the rug were soon gone, too, and men with large bundles of new clothes, blankets, and doilies headed for their cars or buggies.

The Model Ts spit and sputtered, and with dim headlights rumbled home. The buggies and wagons plodded on their ways, horses anticipating feedboxes of sweet oats and luscious hay. Bundled heavily with warm clothes against the cold winter's blast, all of the ladies smiled at the thought of having some new clothes for the kids and maybe some new towels for the kitchen.

The echoes of the auction remained on people's minds, with the beauty of all those new clothes, rugs, tablecloths, and small pieces that had hung over frames used to display the sale items.

That fine group of ladies met their goal that year, as they did every year. Bazaars were held in our little town for years and years, always creating the magic that sealed the community together.

# Prairie Winter

# Winter Butchering

This is a scene familiar to those who grew up on a farm in the earlier part of this century. Most farmers did their own butchering, cutting and wrapping meat for their home use. It was usually a family affair, saved for a cold Saturday in winter when the kids were at home from school.

They might butcher either a beef or a hog, or sometimes both on the same day. Butchering wasn't a big community affair like threshing or silo filling, but close neighbors would get together to help each other and share the work.

The picture conveys a cold, cold day. Light haze rolls against the high windbreak of boards, joining the barn at a gate. The gnarled, scrubby box-elder stands quietly in its dormant solitude.

A fire is going under the big iron pot, the water steaming in the winter air. The geese wonder what all the commotion is about. The two fellows are getting ready to dip a second hog in the hot, steaming water to soften the bristles so they can scrape them off.

They have already dressed the first hog. Its gutted carcass hangs from the singletree, suspended with a block and tackle. The carcass would hang and cure for several days before it was cut up and wrapped.

These men are using a wooden barrel, which was lighter than a metal barrel and easy to handle. Also, the water stayed hot longer in a wooden barrel. The main thing was to have plenty of scalding water to soften the bristly hog-hairs.

Scraping the bristles was a tedious job. Cold would creep into your feet, and toes got numb. After a while, you would draw your loose-fitting jacket tighter, arch your back, and try to relax and just concentrate on the job. Then Mom would surprise you and appear with a steaming cup of hot chocolate and a cookie.

The dog has his eye on the tub where they put two very popular items, the heart and the liver. After butchering, we always had a supper of liver or heart, or both. The over-turned wagon box demonstrates another of its many uses, this time as a table for butchering.

Bacon and ham were popular for farm breakfasts. Every part of the hog that would make good bacon was put in a curing brine, a mixture of salt, sugar, and sodium nitrate or nitrite. It would take from twenty to thirty days to cure. From the hindquarters we'd make ham, curing it or smoking it with seasoning to taste just the way the family preferred.

One of our favorite breakfasts was several slices of bacon on a plate circling three or four pancakes, soaked with homemade maple syrup.

Not everyone scalded and scraped their butchered hogs as shown in this scene. Sometimes the hogs were skinned. I recall one old gentleman hired by my father who skinned and butchered hogs, under three hundred pounds, for $1.50 each. A thousand-pound beef cost $3.00.

After World War II, you could have a meat locker pick up your critter, do the butchering, then wrap, cure, and store your meat, and send you a bill. It was a lot less work for the farmer and made it easier to have fresh meat all year around.

# At the Pump

In the wintertime, ice could form inside a pump and freeze the main piston. To fix this, the tea kettle was an important tool. You would heat the kettle on the cookstove to a healthy boil so it simmered all the way to the pump. A kettle of hot water freed things right up and then you could draw your water.

This type of pump was common on almost all farms through mid-century and later. It is called a lift pump. They are also called suction pumps because they create a partial vacuum when the piston moves up and down in the cylinder. This lifts water up from the well, filling the cylinder until the water is forced out the spout.

Gaskets and leathers helped to create the vacuum to lift the water from the well. These gaskets could dry out, allowing air to slip in. Often they needed to be soaked first so they expanded to make a tighter seal. This was called "priming the pump." Otherwise, any amount of pumping just wouldn't create enough suction to draw the water up.

A bucket was always kept close by with enough water to prime the pump. You just poured water into the top, let things soak for a few seconds, and then the pump was ready to go.

On a farm with a well and no windmill, water was pumped by hand and carried by buckets. During droughts, some farmers had to pump tremendous quantities of water every day for livestock, or gardens, and sometimes carried it long distances. Today's ease of turning on a faucet in a bathroom or kitchen, or spraying water on a shiny new automobile on Saturday afternoon, is a far cry from the labor involved in hauling water on farms in the early part of the century.

One standard caution given to young boys and girls was never to put your tongue or lips on a cold pump-handle in the winter. The tongue could freeze instantly to the pump's metal surface, holding captive anyone so foolish to try it. Yet the mere thought of it was so fascinating that many tried it anyway, or talked a younger sibling into it. It was a painful experience, never to be repeated.

Besides the hand pump by the house, many farms had a second well close to their barn with a windmill to pump water for livestock. Some farm boys will remember the windmill with the label "Air Motor" on its fan-tail, floating back and forth high above the ground. With the new bolt-action 22-caliber rifle that my brother got on his birthday, my first target was one of the "Os" in that label. Those farm boys who weren't so lucky to have windmills had to pump water for their stock by hand. It was a tedious job.

In the early 1920s a device called a pump jack was invented, making pumping water easier. It was a cluster of gears, with one gear set off-center to change a circular motion to an up-and-down action. The pump jack was driven by a belt hooked to a small gasoline engine, the size used on washing machines. Most farmers were very poor and couldn't scrape together enough money to purchase even a small motor like that. Consequently, they still had to pump water by hand.

# Returning Home by Moonlight

Before I was old enough to go to school, I would ride around in the wintertime with my father while he did his work. Wrapped in a coat and scarf, struggling from the weight of my big, red, four-buckle overshoes, I loved to climb into the bobsled to swish through the snow with my favorite team, Nell and Tom. They were a spirited team and I think they knew I loved to go fast. I would urge them on, and they always seemed willing to pick up their pace.

Nell was part Arabian. She was black with a white splash on her face. Her teammate, Tom, was part quarterhorse, sorrel-colored with a full white face. They were a snappy, high-stepping team with great endurance, cheerful in disposition and always willing to work. They were almost a fancy team, but were unmatched by color. Dad always got a compliment on what a fine team they were when he went threshing. Farmers often made him offers to trade or buy, but he always declined.

Besides his own farmwork, my father managed several pieces of land that my grandmother owned. One piece down by the river was mostly timber land and was used to produce firewood. Generally the wood was cut by people who made their payments in shares, rather than cash. The customer would cut the trees, saw them to stove size, and then a third of the wood, or sometimes half, went to Dad. That is how we got our fuel to burn every winter for many years. Dad had to haul his own share.

In the 1920s and '30s, during the Depression, everybody heated with wood. Any other kind of fuel cost money and nobody had any to spend. Cutting and sawing wood was hard labor, but it was something we could harvest ourselves and that was important in lean years.

♦ ♦ ♦

One cold winter morning — I was barely five years old so it was probably 1925 — we left for the timber to pick up some firewood from a bunch of guys who were out there cutting wood. The land was about three miles from home, just on the other side of the Little Sioux River. My brother and sister were off to school, picked up by the local horse-drawn school bus, to my great envy.

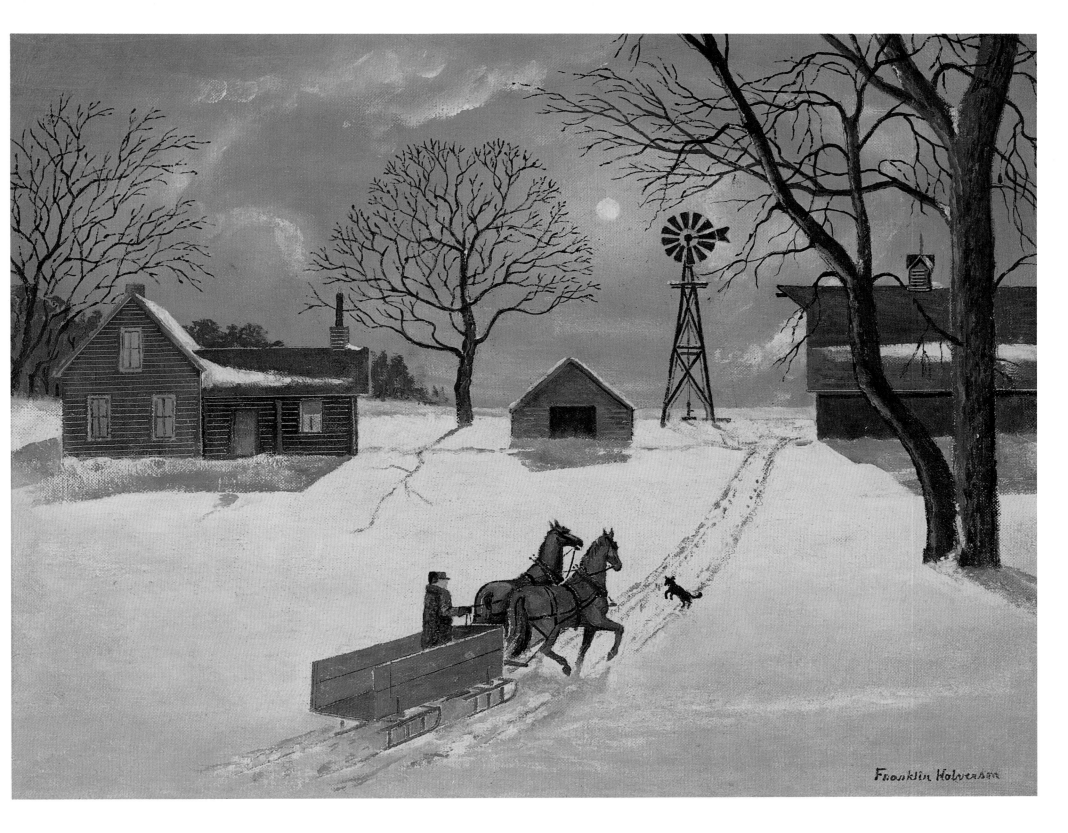

We were going to bring back a load of wood to store in the basement and burn in the furnace. Passing through town, Dad stopped at the grocery store and got some wieners to roast and buns for a sandwich. It would be the first wiener roast of my life.

As we got close to the woods and the river, we heard the hum of the buzz-saw. Powered by a two-cylinder tractor engine, it echoed through the woods. We slowly descended a long trail, seldom used by vehicles, down to the river. Except for the engine in the distance, the silence was shattered only by the blue jays and crows as they screamed and cavorted around the trees and brush. We crossed the frozen river close to where the men were working.

Just as we came up to the buzz-saw, somebody hollered, "Whoa!" The men stopped the saw and discovered, upon examination, they had forgotten to grease a bearing. Smoke and steam rolled out of the saw. The day was over for them. It was a bearing that would have to be poured by an expert. There wasn't a parts-store nearby to purchase a replacement.

We found a good spot to sit and Dad started a fire so we could roast our wieners. He took out the quart jar Mother sent along full of coffee, creamed and sugared. He was anxious to savor its delightful taste. My father never drank lots of coffee but loved at least one cup at each meal, hot, white, and sweet.

He put the jar close to the fire, hoping to warm it a little. As the fire caught and blazed up, though, we heard a sharp clink. The glass jar had cracked. Lunch was disappointing for Father without his coffee, but he let me roast the wieners, and that was a lot of fun for a five-year-old boy. A few of those took the edge off my hunger. We loaded most of the wood the men had already sawed and headed for home. They would finish up when they got their saw back in working order.

We crossed back over the frozen river. The ice was thick enough, but I asked my father about all the sand and dirt scattered over the slippery ice. "Without it, the horses could slip and break their legs, or strain their backs, and then they would have to be destroyed," he told me. When he finished telling me what "destroyed" meant, I didn't even want to talk about it anymore. I loved those horses and I didn't want anything to happen to them.

◆ ◆ ◆

Nearly every little town had an ice house where ice was stored to be sold in the summertime. Harvested from lakes and rivers in the middle of winter, the ice was used to keep food and beverages fresh. We had a brown icebox that stood on our porch or, in summer, in a corner of the kitchen. Mother always tried to keep flowers and a bright, clean cloth draped over it to boost its otherwise drab appearance.

By mid-winter, the ice on lakes and rivers would freeze to become one to two feet thick. The ice harvesters would pick out a big, open spot. With a long, one-man crosscut saw, they cut a rectangular chunk about 30 inches wide, and ten or twelve feet long. Several more of these were cut, then they cut a waterway or channel. With spiked poles, they poked and pushed the slabs of ice to a slide.

Using a horse, sharp-shod and wearing a blanket for warmth, for pulling power, the chunk was pulled up the slide. The men guided it with large ice-tongs up and onto a flat-bed wagon. Each large chunk was placed upright on end, and the wagon was loaded one tier high, one slab at a time. The wagon was like a hayrack with the back end removed, only it had a heavier floor.

When they had the flat-bed full, they slipped a two-by-four in behind the ice to keep it from sliding out. A regular team of horses pulled the wagon to the ice house nearby to be unloaded.

There, the men backed the flat-bed up to a long slide that went upward to a high platform on the side of the ice house. Hooking tongs into each slab, they used a horse to pull the ice out and up to the platform. When it got up there, they unhooked the tongs and pushed the chunk down another slide into the inside of the building. Finally, they pushed the block into position for storage and covered each layer with lots of sawdust.

Harvesting ice took many man-hours of work, and the work was hard. Our small town on the Little Sioux River harvested lots and always had plenty through the summer. Sawdust from local sawmills covered and insulated the ice long into the following summer, when it was cut into smaller chunks and sold. The man driving the ice-wagon delivered the delightfully cool chunks right into our brown icebox.

Hundreds of tons of ice were harvested each winter until after World War II, when refrigerators became available in local hardware and appliance stores.

Horses that worked in the winter had to be shod appropriately. Some teams, also used for fieldwork, had the normal flat horseshoes nailed on. To give better grip on icy ground, there were four calks that could be screwed onto each shoe. For actually working on the ice, a horse would be sharp-shod with specially-made shoes that had blades welded on.

It was dangerous to let horses walk in deep snow with either calks or blades on their shoes. Snow would pack up on the inside of the shoe and the horse's foot could turn over, possibly injuring a leg. When driving a horse in snowy conditions, an owner would stop quite often and dig ice out from the hoof and shoe.

The ingenuity of local ice-harvesters came forth when they figured out a way to mount a buzz-saw on a frame and power it with a Model T engine. The saw was levered down into the ice, as the engine cackled, and was walked along, cutting and spewing ice-dust in neat rows on either side of the blade.

The ice-cutters had seen enough of that six-foot-long, heavy cross-cut saw. The toil of the ice harvesters was relieved as the ice harvest was motorized.

◆ ◆ ◆

On our way home from the woods, we stopped at the local restaurant to warm up and rest a bit. It was always a good place to catch up on local gossip. A small piece of warm apple pie and a glass of milk topped off the wiener sandwiches I had eaten in the woods. Getting warm was the main thing on my mind, and the pie was good, too. Of course, Dad ordered his coffee sugared, white, and hot, with an extra large piece of apple pie.

# Winter Pleasure

The painting shows a fancy cutter, pulled by a pretentious sorrel, getting a stiff challenge from a farmer's team and sled. Heavy snow blankets every corner of the field and road. A sullen winter sky touches the horizon, while a set of farm buildings looks out over the quiet fields.

The farm bobsled, with its splendid gray and bronze horses stepping high and fast, has whizzed by the sorrel. The driver and a passenger of the sled wave to the dressed-up folks in the cutter, without much response. Perhaps the couple in the cutter are a little miffed to have been overtaken so easily.

The farmer's double wagon-box mounted on sled runners was the same wagon used in the summer on four wheels. When snow fell, it took but a few minutes for two men to do the conversion, removing the wheeled running gear and replacing it with bobsled runners for winter use. With roads impassable for cars, the bobsled was used for travel and for daily chores around the farm, too.

There were few luxuries a wagon box offered to keep you warm, but piles of blankets and a thick coat, warm hat, and earflaps or muffs managed to do the trick. Under your feet you could place a hot iron, or brick, heated on the stove before leaving home. As you swished across the cold ground, you were pretty cozy, and the crisp air was invigorating.

The harnesses on the bobsled team and the sorrel are adorned with ivory rings and a traditional fringe of bells. Trees and brambles outline the snowy field and stretch out down the narrow road.

On a late Sunday afternoon in winter, the phone might give a general ring. A voice proclaimed there would be a community hayride tonight. "Leaving the church at seven, come dressed warm!" We hustled and bustled to get the chores all done, and washed the supper dishes in a hurry to get to the church on time.

In those days, people made their own fun. A hayride was always a favorite event. Arriving at the church, you first heard a distant jangle of bells, then several bobsleds appeared, followed by a hayrack with half a "basket" of hay for warmth and seating. The bobsled runners slid gracefully across the packed snow of the churchyard. Horses pumped their heads in anticipation of the run, prancing and straining to be loose.

A few minutes into the ride, an orange blotch low in the east began to grow and grow. Slowly the moon appeared, gorgeously colored as it escaped the horizon and steadily climbed. A strip of cloud hung close to the earth as the moonlight gained strength. The snow sparkled from the bright sphere, and spontaneously, the singing began. You will never see a more beautiful moonrise than one with friends singing and keeping warm in a hayrack.

The temperature is dropping but there is no breeze. The horses are sweating, hot from the long run. Lather shows around the harness and builds up on their backs. The drivers follow the roads around and head back toward the church. The horses trot along faithfully, anxious now to get the hayride over and get back to their stalls.

At the church we quickly leave the hayrack. The owner of the rack and team heads home. He still has a long time to spend walking and cooling down his horses. If he puts the horses away wet, they would catch pneumonia and get very sick. The rest of us head home, too, humming snatches of favorite tunes on our way to bed, and on through the next day.

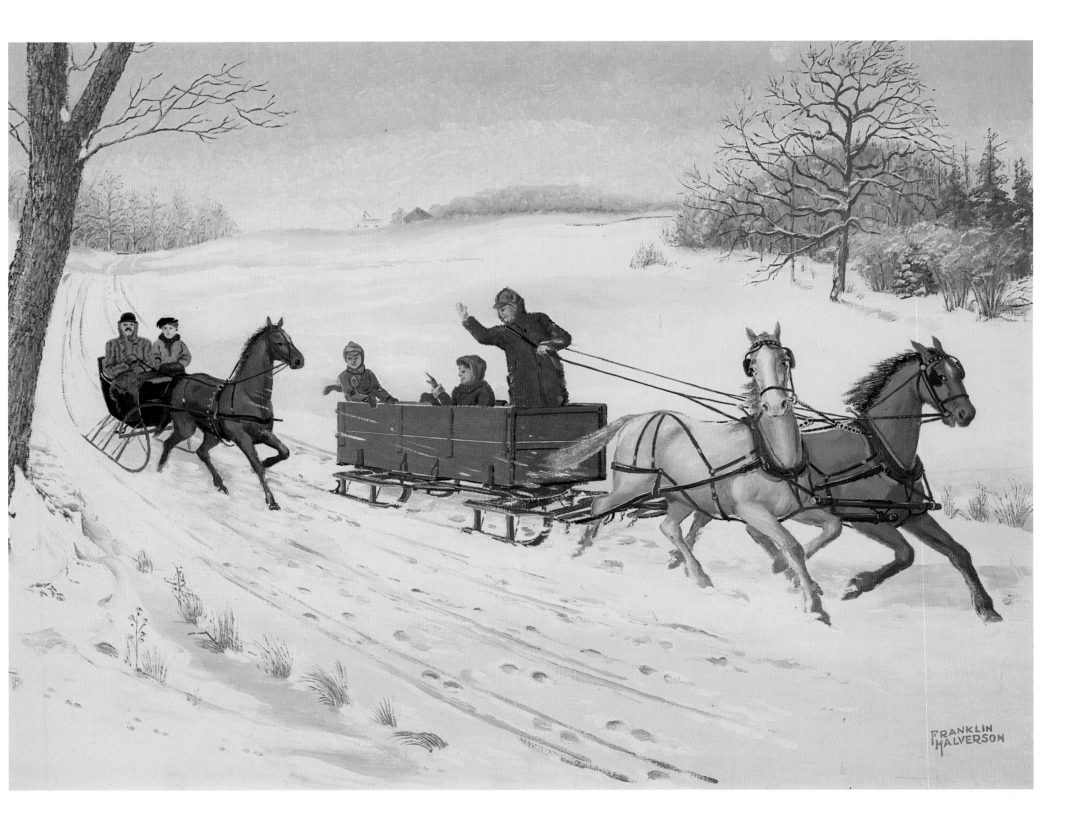

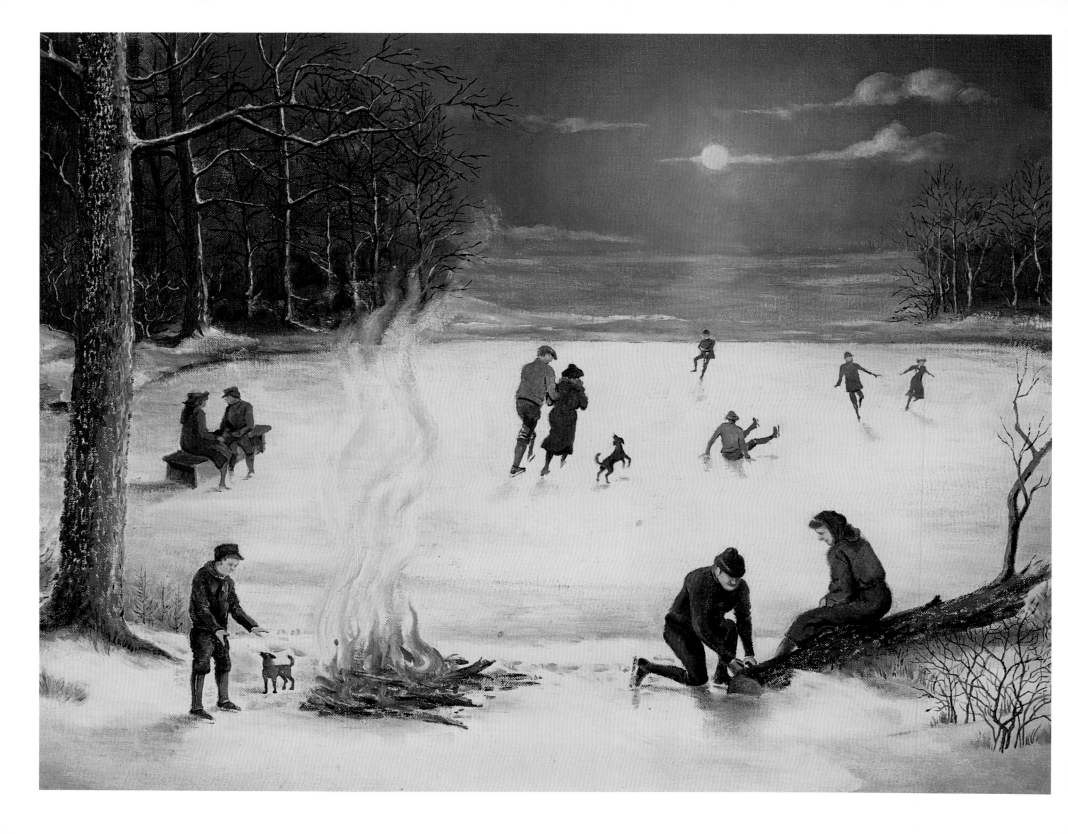

# Ice Skaters

Ice skating under a full moon and a nearly clear sky was a tradition handed down through the years. The pond is frozen solid and clear of snow. An inviting fire greets the skaters. A young boy warms his hands, while his small canine friend waits patiently, ready to chase him across the ice. With the warm fire and bright moon, it was a wonderful moment to sit on a log and have your best friend help you put on your skates.

Partners are enjoying each other's company, just lending an arm or showing off with a fancy move. On a farm pond like this there was room for expert and novice alike, all skating together under the moon on that beautiful winter evening. One young couple, however, is having a fine time just sitting on a bench to the side.

The cluster of tall timber climbs the slopes on either side of the pond. Ice glistens on the trunks. The trees stand patiently, waiting for soft spring rains followed by warm sunny days. The pond looks out onto the rolling prairie, barren under its coat of white. Out there are snow-covered fields of cornstalks, plowed acres of oat stubble, and sleeping pastures of alfalfa. Spring would come, but winter had its pleasures, too.

Skating parties like this got started when a few eager skaters from one of the nearby farms decided to announce a get-together. Perhaps they were struck by a memory of the last time, perhaps a year ago, that they had this rare combination of a full, nearly cloudless moon and a clear, frozen lake that was free of snow. They took to the phone, and the neighborhood party line started to buzz.

A party line had special rings for each family. It might be a short ring and a long ring, or a long ring followed by two shorts and a long. The party line was a source of community information. It was easy to get neighborhood families together for a fun event like ice-skating.

Some would volunteer to get there early and start the fire. If needed, someone would push any light snow or fallen debris off to the side. A hot drink could be fixed at the fire with cookies or cake, or they might plan to meet at someone's house afterward to warm up before heading home.

Few of us had fancy shoe-skates in those days, although I'm sure they were available. We used clamp-on skates, with blades that fit right onto your own shoes. The clamps gripped the soles of the shoes close to the front. A buckled strap encircled the instep and ankle, securing your heel to the back of the skate. High-topped shoes that laced up over the ankles gave the best support. You also wanted to keep your blades nice and sharp to get a better glide on the ice of a farm pond.

To tighten the clamps to grip your shoes, you had a special key. As young kids, we were cautioned not to lay the key on the ice. It seemed like a good place because it was easy to find, but a key laid on the ice could melt itself into the ice surface.

When I attended these skating parties, we'd always pick a partner for a Grand March just before we headed home. As we skated around the pond, pair following pair in a serpentine fashion, someone would always start us out on the right pitch, and we'd have an old-fashioned sing-along as we whizzed around the pond, singing boldly and loud, the words echoing across the snow-white prairie.

# Winter Road

A general ring came over our telephone one morning during the winter of 1936. There was coal available at the elevator in our small town! It was being rationed out in small amounts because it had to be hauled into our town by bobsled from another town six or seven miles away — over fences, plowed fields, and through farmers' yards.

Everyone who grew up in the '30s in Northwest Iowa remembers the winter of 1936. We had six weeks without school because of the cold and snow. The whole community was blocked by heavy snowfall and strong winds.

The telephone office notified everyone using a general ring. This consisted of sixteen short rings on every line, followed by the central office delivering their special message. Emergencies were announced this way. Also, if the grocery store had a big bargain sale, the owner could pay for a general ring sent out over the phone lines.

That day, the general ring informed us that coal in 500-pound loads was available at the elevator. This was also an excuse for farmers to pick up long-delayed mail at the general store.

◆ ◆ ◆

1936 was in the ebb of the Great Depression, yet work was still hard to come by. All through that winter, general rings were sent out to collect strong backs to shovel snow. It was tough duty and the pay was tougher, twenty-five cents an hour for a ten-hour day of scooping. Some fellows worked outside in the bitter cold for as little as one dollar a day.

The gravel roads across the rolling hills and valleys were covered with nearly four feet of snow on the level. The wind was piling it up into drifts even deeper. The mounting drifts covered fences, small buildings, and even smothered livestock if they were caught unprotected out in the open.

During this cold period, fifteen men worked for days trying to clear a five-mile stretch of road between two small towns. They worked in the evenings, beginning at seven o'clock. They had lights, but they were dim. Scooping started soon after leaving town and the evening wore on.

They came to one farmer who couldn't get even his bobsled out onto the road. His buildings bordered a draw and after the storm settled, only three or four feet of the tops of telephone poles and wires

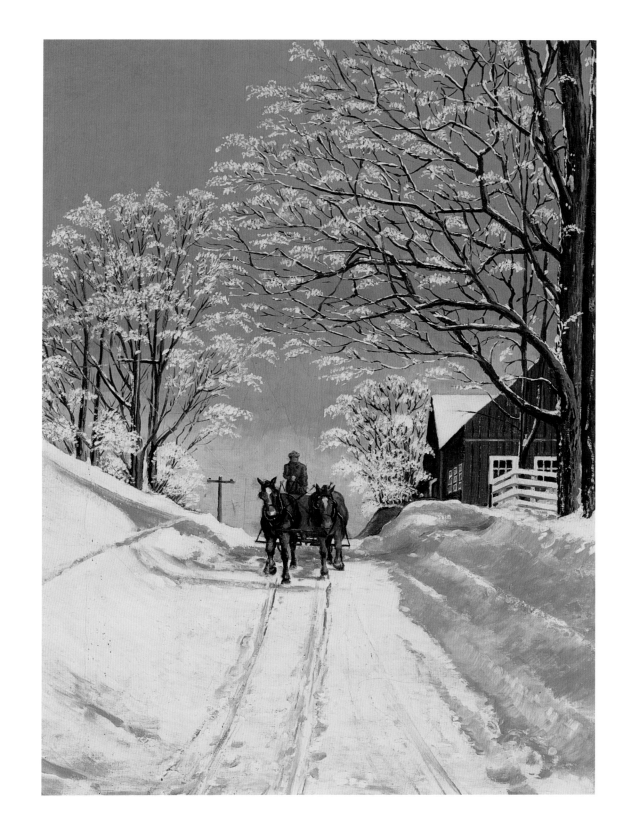

could be seen. The shovelers mentioned the novelty of how easy it was to throw snow over the telephone wires.

At seven o'clock the next morning they had gone five miles. This was with the help of a huge blade on a caterpillar tractor. The shovelers shoveled away the tops of the drifts ahead of the plow, making it easier for the tractor with its crawler tracks to push away the snow. They managed to clear a narrow track, just wide enough for a single vehicle. Only a horse-drawn bobsled could get through because the tractor still left six or eight inches of packed snow on the road. A car would have been quickly stuck.

This channel through the deep snow was passable only until the wind rose again. Sometimes the entire road was filled level with snow again by the next day.

❖ ❖ ❖

I remember my mother calling from the house, telling my father that coal was available and that we had only a few pieces left to burn. Mother also needed groceries to keep us on three meals a day. I was sixteen and a tenth-grader. Wanting to show my worth as a farmer, I volunteered to hitch a team and follow the trail through the fields and ditches to town.

It was bitter cold with a bright sun. The cold was reinforced with a stiff breeze out of the northwest. As my father had said they would, the horses set their own speed. At one long stretch, Beauty halted and pumped her head. We were headed into deeper snow. The trail broke off and went across the ditch, through a cornfield for nearly a mile, then back on the road and on to town.

The sun was so bright I couldn't see the tracks of other bobsleds that had gone before us. The horses had icicles around their mouths, but when I stopped to rest them they seemed eager to get going again. It was bitter cold. Some days during this period, the thermometer never got up to ten below.

As we came into town there was a maze of every kind of bobsled, cutter, or surrey with runners that any farmer could imagine. Most horses stood quietly, others sawed and pumped their heads. The general ring had done its job of informing the community. At the general store, people waited in line to get service. Some had grim faces, talking softly about the weather, wishing winter would end.

The stores had managed to stockpile good supplies of flour and several ladies in town had contracted to bake bread. Regular deliveries of bread and other supplies were impossible, with trucks stuck in other towns. When the train managed to make it through the deep snow to a point several miles north of our town, shovelers and bobsleds met it there and were rewarded with much-needed staples.

I bought whatever groceries I could get from Mother's list and drove to the elevator and got in line for the coal. My enthusiasm to get enough coal was evident when they weighed my load on the scale. I was several hundred pounds over the five hundred allotted. However, the elevator operator said he had plenty at that point and I could take it if I wanted. The added weight for the horses would make a difference later on the trip.

❖ ❖ ❖

The horses had gotten a good rest and were anxious to get home. The sun was on its way down and the temperature was dropping. We followed the trail easily. The town had emptied, as teams hurried to their barns and sheds. The wind was at our backs and had picked up. Long ghost-like sheets of blowing snow slipped over fields of picked corn, disappearing in ditches and draws, finally settling in clusters of trees that bounded the road.

We were within one-half mile of home and faced one more tough pull for the horses. The wind kicked up huge palls of snow as we headed into a deep, rutted draw. The horses were eager to get home to have a drink and get in the barn for a well-earned meal of lush oats and sweet-clover hay.

Before I knew what was going on, both horses were thrashing

about and diving in deep snow. I quickly tried to quiet them but they got excited. Beauty, the right-hand horse, kept straining and struggled, and then went down in the mass of snow. Prince snorted and stood quiet.

The footing underneath was solid ice and Beauty kept thrashing and lunging. Every time her head hit the hard-packed snow, she became weaker. The wind tugged at everything, dropping fine, cold, powdery snow on us, while she grunted and continued to pound her head against the snow. Again and again she lunged.

Finally I managed to step in front of her and grabbed her bridle firmly on each side of her mouth. I spoke her name several times and she regained her composure. I unhitched her and she struggled to her feet, finally standing. I pulled the pin in the doubletree, drove the horses forward a short distance without the bobsled, and hitched them back to the doubletree. I got out the chain that we always carried in the wagon box, secured it to the doubletree, and then secured the other end to the bobsled tongue.

I went around in front of the horses and touched them. Beauty was trembling with fright and exhaustion. But with a few pumps of her head, she indicated she was ready to go. I stood off to the side holding the lines tight as they pulled the sled several hundred feet away from the deep snow and ice.

If she had continued to struggle, Beauty could have injured herself. With the uneven ground and the ice below the snow, she couldn't maintain her footing. Once she went down she became frightened and just panicked.

Both horses were great friends of mine. We were very happy to see our farm appear, to arrive home, tired but safe, with a much-needed load of coal and groceries.

◆ ◆ ◆

It was not until late February that the constant winds slackened and the temperature moderated. Snowplows had been working nearly continuously all this time, leaving deep furrows and covering fences and telephone wires. Our 1935 Ford hadn't been started for over a month. Huge drifts blocking the driveway to the road had to be shoveled before we could move it.

Bright sun and a rising temperature gave us our first warmer days. The livestock became foxy and kicked up their heels when they came to feedbunks and feeders. Roosters crowed more and the old hens got more generous with the number of eggs they laid.

Spring came. Rivers and creeks widened as the snow melted, washing out roads and making barnyards into sloppy mud-puddles. Warm sun revitalized all of us in the community.

As the snow melted, farmers made their plans for spring planting. Things were back to normal.

# PAINTINGS & ACKNOWLEDGEMENTS

## List of Paintings

The paintings are listed in order of appearance in this book. Most of the paintings were not titled by Halverson. In general, we have used a title if known, otherwise have assigned each painting and its companion story a simple descriptive title to fit both.

The titles given below are those used in this book. If a different original title exists, it is given.

The paintings were all done in oil, except for "Lone Tree at Sioux Rapids," originally a color pastel drawing. The size of originals varies from 14" by 22" to 24" by 36".

"n.d." means the painting is undated.

### Front Pages & Introduction

*Frank Colburn's Barn*, n.d.
*Pioneer Homestead*, 1969
*Lone Tree at Sioux Rapids in 1875*,
    pastel, 1969

### Summer on the Farm

*Vacation at Grandpa's*, n.d.
*Schoolyard Fun*, n.d.
*Summer Pasture*, 1968
*High Noon*, 1965
*Milking Time*, 1972
*Early Risers*, n.d.
*The Ice Wagon*, 1964
*Haying Time*, 1972
*A Rainy Day*, 1966

### Neighbors & Townfolk

*Sunday Afternoon Horseshoes*, n.d.
*Main Street (Sioux Rapids)*, 1963
*Village Blacksmith*, 1961
*The General Store*, n.d.
*Depot at Sioux Rapids*, n.d.
*The Flour Mill (Sioux Rapids)*, 1961
*Country Doctor*, 1969
*Traveling Salesman*, n.d.
*Old Couple at the Rain Barrel*, 1968
    (original title: "Negus")
*Horse Breaking*, n.d.
*Barn Raising*, n.d.

### Harvest Time

*The Oat Harvest*, 1968
*Threshing*, n.d.
*Quitting Time*, 1961
*The Corn Picker*, 1961
*Shocking Corn*, n.d.
    (original title: "Corn Harvest")
*Digging Potatoes*, 1969
*Harvest Moon*, 1969

### Prairie Winter

*Winter Butchering*, n.d.
*At the Pump*, n.d.
*Returning Home by Moonlight*, n.d.
*Winter Pleasure*, n.d.
*Ice Skaters*, n.d.
*Winter Road*, 1965

## In Sincere Appreciation

This book would not have been possible without the kind help of many individuals and organizations, reflecting the spirit of neighborliness embodied in Franklin Halverson's paintings. We would like especially to thank the following folks for their support in creating this documentary publication.

Pete Aarsvold
Harry Adams
Albert City Historical Assn.
Carlo Andersen
Sam Andersen
Mrs. Gunnard L. Anderson
Dick Aronson
Arts on Grand Art Center
Ruth & Martha Helen Barnard
Greg Bass
Tom Bass
Marc & Jacki Bertness
Mr. & Mrs. Raymond Bertness
Buena Vista County
Buena Vista County Historical and
    Genealogical Society
Marvin Burke Photography
Mr. & Mrs. G. Richard Burr
Raymond Daugherty
Tina Donath
First National Bank of Sioux Rapids
Billie & Donna Frederick
Chuck Gould
Gary & Wanda Grote
Ardyth Hadenfeldt
Mr. & Mrs. Boyd Halverson
Junior & Barbara Halverson
Mr. & Mrs. Lee Halverson
Jerry Hammes
Arden & Shirley Hamrick
Roger & Lois Hanson
Wayne & Jane Hanson
Paul Havens
Gerine Huckelberry
Iowa Arts Council
Prim Jackson
Chris & Anne Johnson
Chrystal Johnson
Debbie Johnson
Jean Marie Johnson
Mr. & Mrs. Merlin Landsness
Ruth Lindroth
Gordon Linge
Veryl Matthiesen
Jeff Meyers Photo
Allan & Michele Mickelson
Lola Colburn Moe
Mt. Horeb Area Historical Society
Mike Mudrey
Steve Ohrn
Dr. & Mrs. Arnold Olson
Keith Paul
Roger & Pat Redig
Don Rehnstrom
Mark Rooney
Kenneth Salton
Sioux Rapids Area Historical Assn.
Allen & Gayla Sorenson
Robert & Shirley Stewart
John Stowe
Paul Swaim
Louis & Gayla Voss
Bruce Williams

# FURTHER RESOURCES

## Books of Farm Memories

Chester Garthwaite. *Threshing Days: The Farm Paintings of Lavern Kammerude.* Mount Horeb, WI: Wisconsin Folk Museum, 1990. Colorful paintings and companion stories follow the farmer of the 1920s and '30s through the seasons of the year.

Ronald Jager. *Eighty Acres: Elegy for a Family Farm.* Boston: Beacon Press, 1990. Delightfully insightful account of a boyhood on a Michigan farm in the 1930s and '40s.

Ben Logan. *The Land Remembers: The Story of a Farm and Its People.* Minocqua, WI: Heartland Press, 1975. A heartfelt novel of growing up on a Wisconsin farm in the 1920s and '30s.

Beulah Meier Pelton. *We Belong to the Land: Memories of a Midwesterner.* Ames, IA: Iowa State University Press, 1984. An engaging, often humorous portrait of life on an Iowa farm from the 1920s to '50s, from a farmwife's point of view.

## Especially for Children

Cheryl Walsh Belleville. *Farming Today, Yesterday's Way.* Minneapolis: Carolrhoda Books, Inc., 1984. Wonderful photos and companion text follow a modern-day family, farming with draft horses, through the year.

## Other Studies of Farming, Farm Technology, and Traditional Culture

Wendell Berry. *The Unsettling of America: Culture & Agriculture.* New York: Avon Books, 1978. A thoughtful set of essays on the dangers of over-zealous modernization to farming and American culture.

R. Douglas Hurt. *American Farm Tools from Hand-Power to Steam-Power.* Manhattan, KS: Sunflower University Press, 1982. Good reference work on historic farm implements.

Thomas D. Isern. *Bull Threshers & Bindlestiffs: Harvesting and Threshing on the North American Plains.* Lawrence, KS: University of Kansas Press, 1990. On the interaction of regional culture, environment, and technology, by a historian at Emporia State University in Kansas.

J. Sanford Rikoon. *Threshing in the Midwest 1820-1940: A Study of Traditional Culture and Technological Change.* Bloomington and Indianapolis: Indiana University Press, 1988. Based on field interviews with older farmers and other diverse sources, by a rural sociologist from the University of Missouri.

**To order books, contact your local bookseller.**

## Selected Museums

Iowa Living History Farms. Des Moines, Iowa. Open daily May to mid-October; 600-acre site presents Midwestern agriculture and rural life, including an 1850 farm, an 1875 town, a 1900 farm, exhibits of modern farming, costumed interpretive staff, craft demonstrations, and more. Address: 2600 NW 111 Street, Urbandale, IA 50322. Tel: (515) 278-5286.

Lake Farmpark. Kirtland, Ohio. Open daily year-round; farm animals, demonstrations of milking by hand and machine, working with horses and oxen, seasonal exhibits, wagon rides, plant science center, special events, and more. Address: 8800 Chardon Rd., Kirtland, OH 44094. Tel: (800) 366-3276.

Midwest Old Threshers Heritage Museums. Mt. Pleasant, Iowa. Two museums, one of gas tractors and steam engines, one of exhibits showing life on the Iowa frontier, the role of women on the farm, early implements, and more. Open daily Memorial Day to Labor Day; also Monday to Friday, mid-April to mid-October. Sponsors a five-day Old Threshers Reunion, ending each Labor Day. Address: 1887 Threshers Rd., Mt. Pleasant, IA 52641. Tel: (319) 385-8937.

## Directories & Periodicals

*Annual Steam and Gas Show Directory.* Annual listing, available each March, of hundreds of events organized by state and by month: threshing reunions, farm-machinery exhibits, museum displays. Write: Stemgas Publishing Co., P.O. Box 328, Lancaster, PA 17603.

*Draft Horse Journal.* Published quarterly. Box 670, Waverly, Iowa 50677. Tel: (319) 352-4046. Information on draft-horse events, and articles on farm and draft-horse heritage.

*Midwest Open-Air Museums Magazine.* Published quarterly. Write: Judith Sheridan, Treas., 8774 Route 45 NW, North Bloomfield, OH 44450. Tel: (216) 685-4410. Articles and schedule of events for open-air museums across the region.